Rembrandt

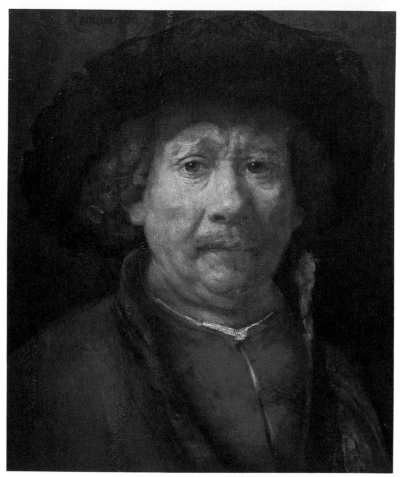

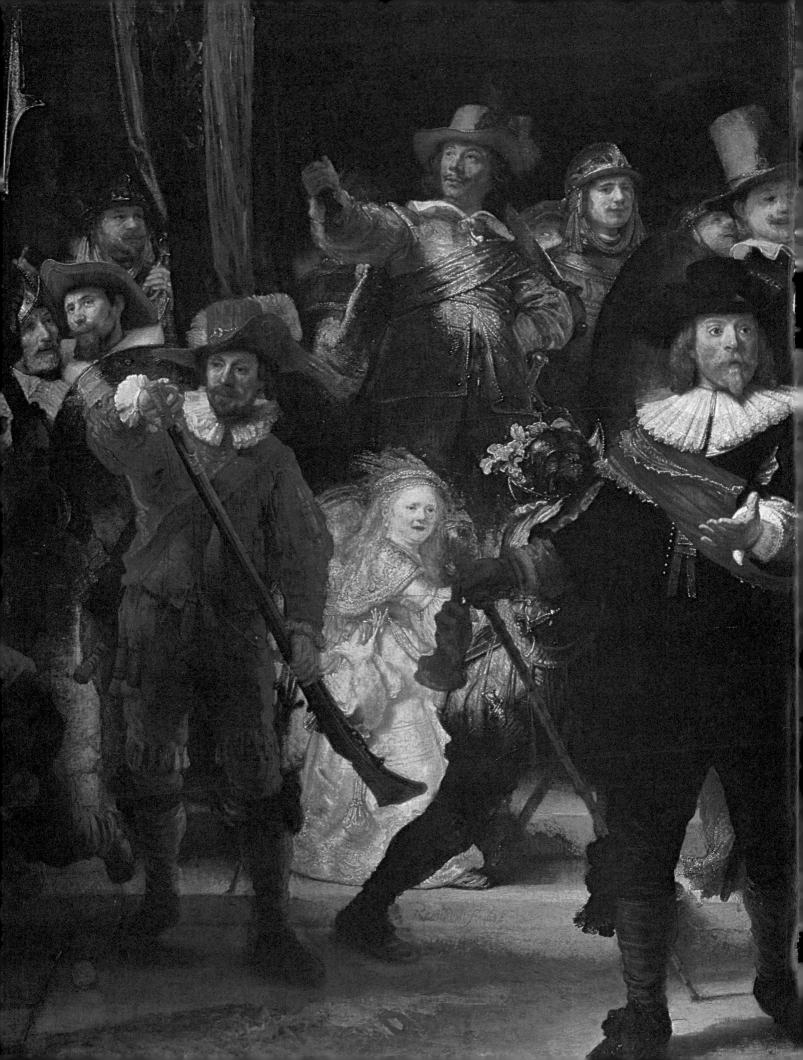

Rembrandt

John Jacob

CHARTWELL
BOOKS, INC.

HALF-TITLE PAGE *Self-portrait* (c. 1657),
Vienna: Kunsthistorisches Museum, Gemäldegalerie

TITLE SPREAD *The militia company of Captain
Frans Banning Cocq* ('The night watch') (1642),
Amsterdam: Rijksmuseum. Described on page 24

THIS SPREAD *Winter landscape with skaters* (1646),
Kassel: Staatliche Kunstsammlungen, Gemäldegalerie

First published in Great Britain in 1981 by
Octopus Books Limited

This 1990 edition
Published by
CHARTWELL BOOKS, INC.
A Division of **BOOK SALES, INC.**
110 Enterprise Avenue
Secaucus, New Jersey 07094

ISBN 1-55521-598-X

Printed in Hong Kong

Contents

Rembrandt and His World 6

From Apprentice to Master 14

The Great Years 22

The Last Years 50

Index 64

Rembrandt and His World

Rembrandt Harmenszoon van Rijn was born in Leyden, in the province of Holland, on 15 July 1606. He was born into a Europe divided into Catholic and Protestant powers – Spain and Portugal on the one hand, and England and the emergent United Dutch Provinces on the other. The presence of warring armies was a recent memory: in 1573 the Duke of Alba with a Spanish army had laid siege to Leyden, which was relieved only by desperate measures. William of Orange ('the Silent'), leader of the defensive union of the Seven Provinces, breached the dykes and created a shallow inland sea to deliver the town with his strange, flat-bottomed navy of 'sea beggars'.

Leyden was a rich manufacturing town, second in size only to Amsterdam. The Old Rhine bordered the town on one side, with its ceaseless flow of boats and barges; on the other was a wide canal known as the Rapenburg. Leyden's university was already famous, and was first in the Seven Provinces by reason of both its size and its academic reputation, which attracted foreigners from near and far.

Just outside this proud, elegant town Rembrandt's paternal grandmother and her second husband bought a windmill in 1575 – two years after the Duke of Alba's siege. It was here that Rembrandt's father, Harmen, set up as a miller and conveniently took a baker's daughter to wife. Rembrandt was probably born in the Weddesteeg, a small street on the north of the town close to the windmill in which his father had a half share.

Rembrandt was the sixth of seven children in a family that was by no means rich, but which we can assume was comfortably off. Millers were traditionally well-fed and stout, 'aristocrats' of the working class and occupying a position in the social hierarchy between the peasant farmer and the city merchant. Rembrandt's father seems to have been no exception, and although many of his son's early models have been known as 'the artist's father', the one documented likeness of him, drawn shortly before his death in 1630, shows a thick-set man with a broad nose and full moustache and beard, his narrow eyes closed, lost in his own mundane thoughts. Rembrandt's mother, Neeltge van Suydtbroek, on the other hand, lived on for 10 years after her husband's death. A stern, pious woman, whose principal reading seems to have been the Bible, it may be she who appears as an old lady in a number of her son's early works.

Three years after Rembrandt was born the Dutch people achieved one of the landmarks in their hard-won independence from Spain. By the Twelve Years Truce of 1609 Spain finally recognised the independence of her northern provinces, and the peace ushered in the greatest period of Dutch culture and prosperity. No northern artist could have been more fortunate than Rembrandt in the timing of his birth. The discovery at the end of the 16th century of the route to the East Indies led to the foundation in 1600 of the United Dutch East India Company and the systematic hounding by Dutch and English freebooters of the Spanish and Portuguese colonies in Africa and Asia. In the early years of the 17th century some of the most valuable colonies – from the Cape of Good Hope to India, Ceylon, the East Indies, and even to the coast of China – fell into Protestant Dutch and English hands. The cultural effects were incalculable, as the colonisers ransacked the wealth of the east: Rembrandt, for instance, is known to have had in his collection of works of art an album of Indian Mogul miniatures. In 1621 a West India Company was founded which established trading posts in Brazil, while in North

The prophet Jeremiah mourning over the destruction of Jerusalem
1630*
Oil on panel
58 × 46 cm (22$\frac{7}{8}$ × 18 in)
Amsterdam: Rijksmuseum

This is generally taken to be one of Rembrandt's early religious paintings. In spite of the immense vessel filled with golden chalices in front of the figure and the rich rug beneath the Bible on which the prophet rests his elbow, the work certainly seems to be suffused by a rather 'puritan' melancholy. It is possible that Rembrandt was a Mennonite, as his early biographer, the Italian Filippo Baldinucci, suggested. If so his religious belief would have been founded upon a literal interpretation of the Bible and a preference – which Rembrandt undoubtedly showed in his later life – for the poor in spirit as against the rich and worldly-wise. Ironically, however, the subject of the picture has never been established beyond doubt (the title is not Rembrandt's): it is quite possible that it represents an old man lamenting the loss of his possessions as the result of some financial catastrophe.

*Most of the paintings are signed and dated. Where there is no signature or the date is uncertain, an approximate date has been indicated by the letter 'c'.

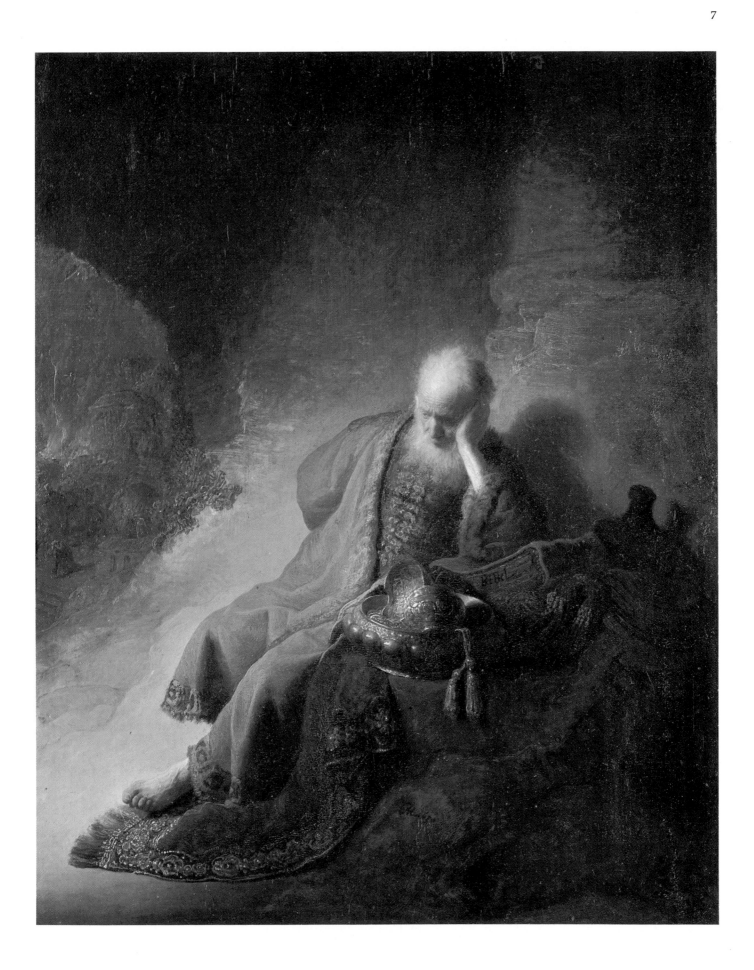

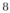

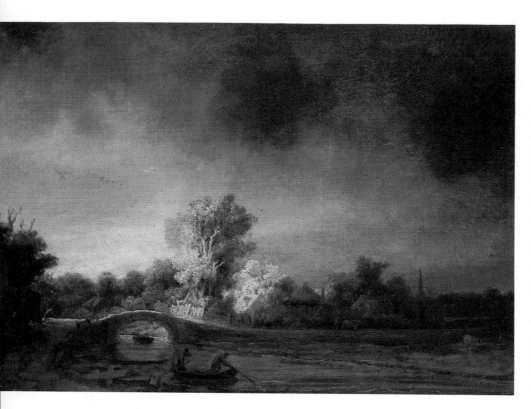

Landscape with a stone bridge
c. 1636
Oil on panel
29.5 × 42.5 cm (11⅝ × 16¾ in)
Amsterdam: Rijksmuseum

Whereas Rembrandt's younger contemporaries Philips de Koninck and Meindert Hobbema made their reputations as landscape painters, Rembrandt himself painted relatively few 'pure' landscapes, although he made abundant drawings and etchings of the countryside around Amsterdam. In his middle years he was in the habit of walking in the open countryside, often along the banks of the river Amstel towards Ouderkerk, and some of his greatest etchings are of the group of windmills and houses, known as the Omval, on the river. In his paintings of landscape, as here, he was particularly concerned with presenting the contrasting light and dark areas in the Baroque style, but there is no mistaking the Dutch character of this scene.

America a fortified Dutch settlement, at the mouth of the river which Henry Hudson had discovered in 1609, was named Nieuw Amsterdam (later to be called New York). These new colonies enriched the United Provinces, in particular the maritime province of Holland, and strengthened their new-found independence.

War with Spain was resumed in 1621, but the struggle between the Protestant and Catholic powers of Europe was now centred on Germany, where that most exhausting struggle of the 17th century, the Thirty Years War, had broken out three years previously. Dutch naval power ensured that maritime trade continued, however, and Amsterdam, like Antwerp before it, became the entrepôt of the world, and on its wharfs lay exotic merchandise from east and west.

The early years of the 17th century also saw great building activity in Amsterdam; her large new churches were built, and a start was made on the three great horseshoe-shaped canals, the *grachten*, which still link the different parts of the modern city. Under the leading architect of the time, Hendrick de Keyser, the typical tall Dutch houses, built of red brick, with stepped and decorated gables, gave the city the character it retains to this day. Merchants of every nation thronged its quays, and foreigners commented that its harbour looked like a forest, so close-thronged were the masts of shipping.

It was here that Rembrandt was to find his more exotic models, and perhaps draw inspiration for the bejewelled turbans that adorn his many 'orientals'. It was merchants and professional men of this city who were to be Rembrandt's early patrons: the new, red-brick houses were hung, in Protestant bourgeois style, not with devotional pictures but with portraits of the merchant and his wife and their children. This sturdy bourgeoisie also commissioned group portraits, landscapes, sea-pieces, or scenes of domestic life known as *genre* pictures. Their dining parlours sported immense 'breakfast pieces' – still-lifes piled high with hams and fruit surrounding a favourite china dish or golden goblet – while flower-pieces reflected the amazing 'tulipomania' of the period.

The connection between capitalism and Calvinism was as apparent in Holland as it was in Switzerland, and Amsterdam became a crossroads for religion and learning as well as for trade. After the Synod of Dordrecht in 1618, religious groups and sects came to practise freely: Calvinists,

A man in oriental costume
1635
Oil on panel
72 × 54.5 cm (28⅜ × 21½ in)
Amsterdam: Rijksmuseum

This portrait of a man in oriental costume was probably painted as a study for an Old Testament figure such as Saul, or even for the main figure in *The feast of Belshazzar* (see pages 30–1), which was probably also painted in 1635. The rich cloths, and the jewels, both in the turban and hanging as a pendant from the chain that fastens the cloak, are a reminder that Amsterdam, then as now, was a centre for the diamond trade. Rembrandt must have seen such jewellery, with its Renaissance mounts, in the leather pouches of Jewish merchants or at auctions when he was acquiring examples for his own collection. The light in the painting is golden, from an unidentified source. The model, perhaps found on the quays, with his strong features and resolute gaze, is one of the most powerful Rembrandt ever used.

Lutherans, Mennonites, and Armenian Remonstrants lived side by side. There was also a thriving Jewish community, and one of Rembrandt's friends was the Portuguese author, Rabbi Menasseh ben Israel, whose visit to England was to lead to Cromwell's re-admission of the Jews.

Nor were the visual arts ignored: the salerooms were full of furniture, arms, hangings, and pictures – on which Rembrandt was to draw. Dealers and collectors abounded; prominent among them was Alfonzo Lopez, a wealthy Spanish Jew, who owned Titian's so-called *Portrait of Ariosto*. Although Rembrandt never visited Italy he was no stranger to classical statuary and he was greatly influenced by the paintings of the Italian High Renaissance. In 1639, the picture collection of Lucas van Uffelen was auctioned in Amsterdam. It contained Raphael's celebrated portrait of the Italian courtier Baldassare Castiglione. Rembrandt made a

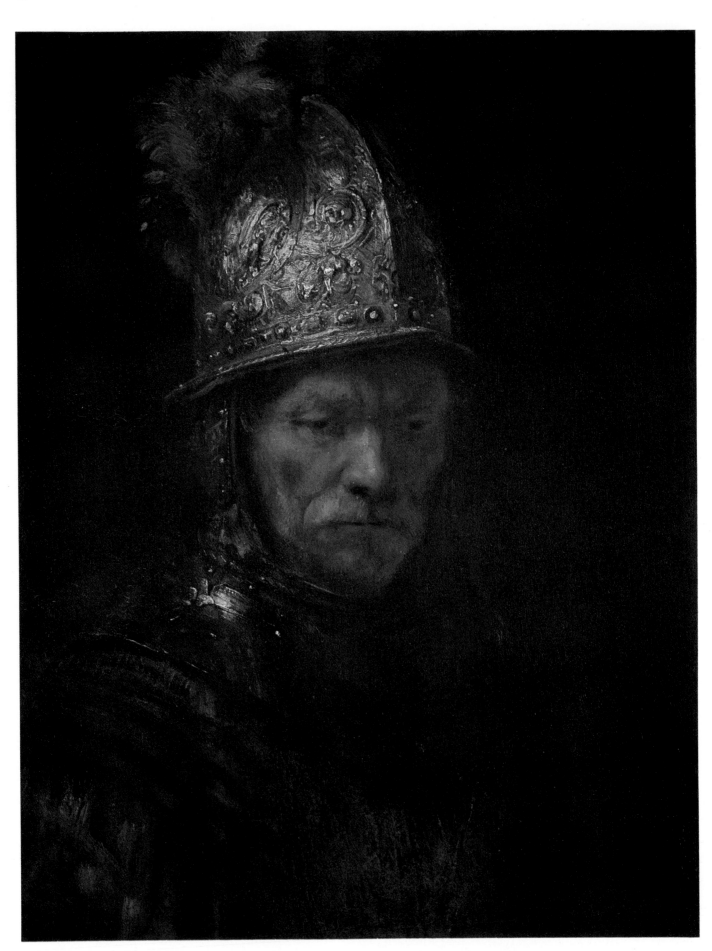

Maria Trip, daughter of Alotta Adriaensdr
1639
Oil on panel
107 × 82 cm (42⅛ × 32⅜ in)
Amsterdam: Rijksmuseum (on loan from the Van Weede Family Foundation)

This is one of the most glamorous of Rembrandt's early portraits of the Dutch merchant class. The sitter was the daughter of Alotta Adriansdr., who in 1609 had married Elias Trip the ironmaster; the latter's brother Jacob, a Dordrecht merchant, and his wife were also painted (in old age) by Rembrandt. The portrait of Maria is painted in a careful, detailed technique that is uncharacteristic of Rembrandt even at this period. It is painted on a *djati*-wood panel from Indonesia – one of the results of Dutch trade with the East Indies – which may account for its rather impersonal handling. Rembrandt made a preparatory drawing for this portrait which, besides being typically vigorous, also shows that the final version has been cut down on all four sides.

The man with the golden helmet
1648–50
Oil on canvas
67 × 50 cm (26⅜ × 19¾ in)
West Berlin: Staatliche Museen Preussischer Kulturbesitz, Gemäldegalerie

It has been suggested that the model in this and other studies, including one of 1654, is Rembrandt's brother Adriaen van Rijn; there are certain facial similarities to the painter. Adriaen, who started life as a cobbler before becoming a miller, spent all his life in Leyden, where he died in 1652. The golden helmet is splendidly painted with a thick *impasto*, contrasting with the thinly painted face, which gives the picture variety and liveliness. Several helmets, antique even in Rembrandt's time, occur in the inventory of his painting room, together with examples of arms and armour, which were used as 'props' in a number of pictures. Such accoutrements no doubt frequently came up for sale on the Amsterdam market, testimony to the 80-year struggle of the Seven Provinces against their Spanish overlords.

quick drawing of the portrait, scribbling the price ('Sold for 3,500 guilders) by its side. It was bought by Alfonzo Lopez. The Titian and the Raphael must have made a lasting impression on Rembrandt, for in the following year he painted a self-portrait (see page 13) posing himself with the cap seen in his sketch of Castiglione, while his expression and the treatment of the sleeve of his cloak on the stone ledge owes much to the *Ariosto* of Titian. We know from the inventory of Rembrandt's possessions drawn up in 1656 that he had a gallery of busts of Roman Emperors, a Homer, a Socrates, and an Aristotle. He also had a collection of art books including *The Precious Book of Andrea Mantegna* by the most 'classicising' of Italian 15th-century artists. Rembrandt, then, may not have travelled; but nonetheless his work is steeped in the art of the Italian Renaissance. In Amsterdam he found the education of an artist.

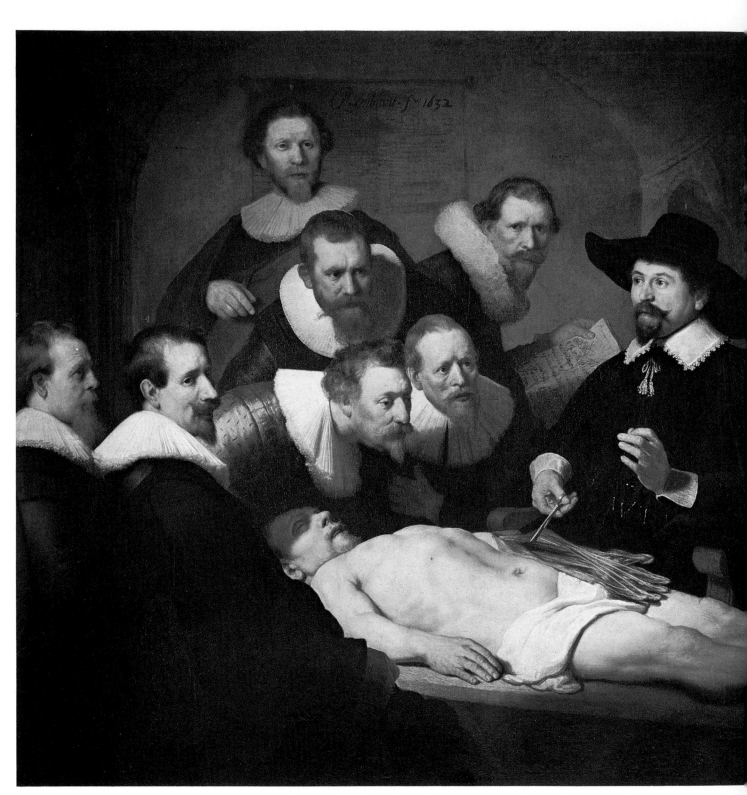

Dr Nicolaes Tulp demonstrating the anatomy of the arm
1632
Oil on canvas
169.5 × 216.5 cm (66¾ × 85¼ in)
The Hague: Mauritshius

This famous portrait group was Rembrandt's first important commission after he had settled in Amsterdam. Dr Tulp (1593–1674)

had studied in Leyden and was regarded by his contemporaries as the greatest anatomist in Amsterdam. He was a senior official of the Amsterdam Gild of Surgeons, a city counsellor who became eight times City Treasurer, and he served as one of the burgomasters of the city on four occasions. Although rather narrow in his outlook on art and religion he may have been

influential in furthering Rembrandt's career. In this painting Rembrandt depicted what appears to be a private lesson on the anatomy of the arm (the details of which he may have taken from an anatomy book) rather than a public demonstration in an anatomy theatre, which usually started with the abdomen. His grouping of the absorbed members of the gild around the

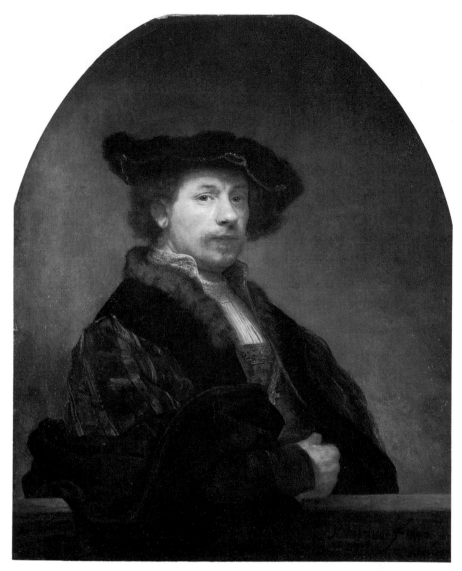

Self-portrait at the age of thirty-four
1640
Oil on canvas
102 × 80 cm (40⅛ × 31½ in)
London: National Gallery

This portrait demonstrates
Rembrandt's debt to the Italian
Renaissance and, in particular, to
Titian, the great Venetian. It is
a picture which marks the
beginnings of his maturity and of
that process of self-analysis and
scrutiny which was to inform the
later portraits of himself. The pose is
taken from Titian's so-called *Portrait
of Ariosto*, combined with elements
of Raphael's *Castiglione*, both in the
collection of Alfonzo Lopez in
Amsterdam; Rembrandt's drawing of
the *Castiglione* may have been done
from memory at the time of its sale
in 1639. The rakish tilt of the beret
has more in common with his own
etched self-portrait of that year
(which anticipated this painting)
than with Raphael's original serene
conception.

lifeless body of the corpse is a
skilful blending of realism with the
ideal conventions of the group
portrait. The figure at the extreme
left and the tall figure at the back
may have been added later.

From Apprentice to Master

We have no idea when Rembrandt, the miller's son, first showed his talents as an artist. At the age of seven, no doubt as the most intelligent child of the family, he was sent to the Latin School where he received a thorough grounding in that language. On 20 May 1620, at the age of 14, he was enrolled as a student at Leyden university, and although he did not stay more than a few months, a Latin entry in the university register – *20 Mai 1620 Rembrandus Hermanni Leydensis studioso litterarum annov' 14 apud parentes* – is the very first reference to the artist in contemporary documents.

There is no reason why an artist should feel obliged to document his own career except by his works – although, as Kenneth Clark has said, 'no art historian likes his artist to travel without his knowledge'. But with Rembrandt, who more than any other artist has left us a visual chronicle of his own appearance and that of his family and friends throughout his life, the written records are infuriatingly formal and scanty. We have only the bare facts at every stage of his life from legal documents, purchases of property, and registers of births and burials. The self-portraits may *seem* to express thoughts, but they cannot *speak*, and much must remain conjecture. Rembrandt's early biographers do not help, and are often in error. Even his own letters to his patron, Constantyn Huygens, are only seven in number and are rigidly formal business letters at that. It is, however, possible to clothe the facts with the works, to interpret the abundant drawings, etchings, and paintings in such a way that we can approximate the great man's thoughts and habits, and approach to an understanding. Such a process is bound to be chancy, and has in the past produced an over-romantic interpretation.

We do not know what led him to forsake his studies at Leyden university, but his passion for painting must have declared itself, and his parents apprenticed him to a local painter, Jacob van Swanenburgh (*c.* 1571–1638). Rembrandt stayed with Swanenburgh, who had been to Italy and had a Neapolitan wife, for about three years (1621–4). He seems to have received a thorough training in the techniques of painting, but of his early style we know nothing. Then, in 1624, Rembrandt was sent to Amsterdam and worked for six months in the studio of Pieter Lastman (1583–1633). The effect on him was to be as lasting as Swanenburgh's influence was insignificant. Lastman was one of the most important Dutch artists of his day; he had been to Italy, where he had been influenced by the Baroque painter Caravaggio, and was the master of a fluent, 'knobbly' handling of paint which was to become a mannerism of the young Rembrandt. Lastman's stock-in-trade was biblical and mythological scenes painted with an over-dramatic, Baroque contrast of light and dark, which were to be Rembrandt's models for the next few years.

By 1625 Rembrandt was back in Leyden, and his earliest surviving picture, *The martyrdom of St Stephen* (see page 16), signed and dated that year, shows the influence of the German painter Adam Elsheimer (1578–1610), for whom Rembrandt shared with Lastman a high regard. Rembrandt was only 19 when he painted this picture; he had set up as a painter in his own right, and seems to have been well regarded by the townspeople, who were no doubt proud of the miller's son. Another sign of his growing acceptance and maturity was the taking on of his first pupil, Gerrit Dou, in 1628. Dou was then a boy of 14 and he probably stayed with Rembrandt, the first of a long line of pupils, until Rembrandt moved to Amsterdam in 1631. Also in Leyden was another former pupil of

Anna accused by Tobit of stealing the kid
1626
Oil on panel
39.5 × 30 cm ($15\frac{1}{2}$ × $11\frac{7}{8}$ in)
Amsterdam: Rijksmuseum

This appealing picture demonstrates Rembrandt's powers as a story-teller. The composition may have been derived from paintings by Willem Buytewech (d. 1624) and Maerten van Heemskerck (1498–1574). but Rembrandt invested his domestic scene of the blind man and his wife with a warm, almost humorous sympathy. The Book of Tobit in the Apocrypha at that time shared with the story of Jonah and the whale the claim to be the most frequently illustrated in the Bible. Among the homely details – spinning wheel, wicker basket, onions – Rembrandt has not forgotten another character from the story, Tobit's son Tobias's faithful dog, which looks out at us knowingly from in front of the fire.

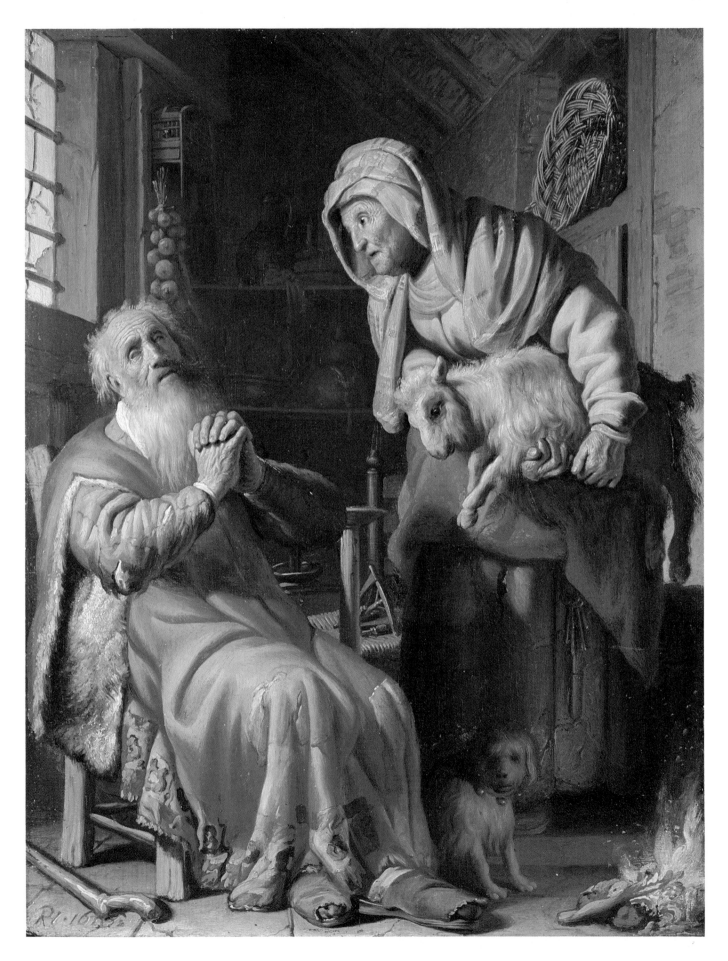

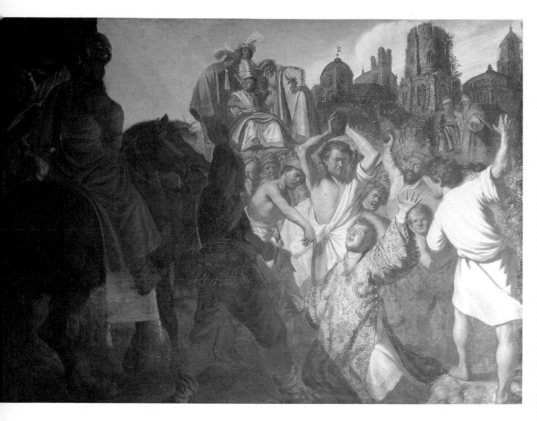

The martyrdom of St Stephen
1625
Oil on panel
89.5 × 123.5 cm (35¼ × 48⅝ in)
Lyons: Musée des Beaux-Arts

The earliest of Rembrandt's dated paintings, this was done in the year after he left Pieter Lastman's studio. Another panel, dated 1626, of the same size, which may have been its pair, is in the municipal museum at Leyden. In both paintings Rembrandt has probably included portraits of himself, and the head to the right of St Stephen's outstretched hand may be a portrait of Jan Lievens. The influence of Lastman is evident in the fluent style of the background of this painting. There is also a link with the German, Adam Elsheimer, whose long-lost painting on the same subject was found in a cupboard in a house in Edinburgh in 1965. Peter Paul Rubens (1577–1640) certainly knew the Elsheimer, for he made a drawing of it (now in the British Museum). Rembrandt, too, seems to have been familiar with it: his turbaned figure on horseback on the right, the vestments of St Stephen, and the distant architecture all have affinities with similar elements in the German picture.

Lastman's, Jan Lievens (1607–74), who although a year younger than Rembrandt had entered Lastman's studio a few years before him. The two young painters became closely associated and may have shared a studio together; certainly their works at this period are often indistinguishable.

Their reputation spread, and in the winter of 1626–7 Lievens was commissioned to paint a portrait of Constantyn Huygens, who was Secretary to the Stadholder, Prince Frederick Henry of Orange. Huygens was to be married in April 1627, and the picture may have been intended as a wedding portrait. Huygens was not only a distinguished diplomat and courtier but a talented *dilettante* and amateur of the arts. Ten years older than Rembrandt, as a young man he had himself intended to become a painter. Now, at the outset of his career with the house of Orange, which he was to serve as secretary and artistic adviser for the next 60 years, he was an important man to know. Besides writing Latin verses, Huygens kept a diary and wrote an autobiography.

In 1629 he visited Leyden and wrote a series of personal notes, commenting perhaps over-patriotically and with inverted snobbery that 'the miller's son Rembrandt and the embroiderer's son Lievens were already on a par with the famous painters, and would soon surpass them'. He chided them for not making the journey to Italy and studying the works of Michelangelo and Raphael in Rome, but the two young painters proudly replied that in the 'flower of their youth' they had no time to spare for an Italian journey. Moreover, they added (and one can perhaps sense Rembrandt as the spokesman) that some of the finest Italian art was to be seen in Holland, and they could find all they wanted here.

Huygens found Rembrandt excelled in judgment and a liveliness of emotional expression, while Lievens was notable for invention, a boldness of subject matter, and a superb sense of form. He praised Rembrandt's recent painting of *Judas returning the thirty pieces of silver* (see page 17), in which the reactions of the priests, horrified and huddling together in mutual apprehension, are wonderfully observed; above all, he praised the kneeling figure of Judas, which was to become a symbol of agony and remorse in the engravings of the time.

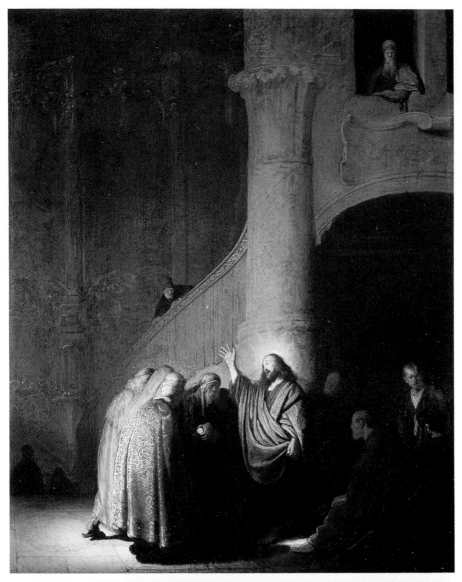

The tribute money
1629
Oil on panel
41 × 33 cm (16 × 13 in)
Ottawa: National Gallery of Canada

This small, dark New Testament
scene is typical of Rembrandt's
biblical pictures of the late 1620s
and early 1630s. He took great pains
with the composition, which is
almost abstract in its balancing of
architectural detail with bold, black
masses. The motif of the curving, or
spiral, staircase had a fascination
for him at this time (see also pages
22–3). Notice the face on the stair, to
which Christ's light, outstretched
hand involuntarily points, and
which leads the eye up, past the
lotus-leaf capital on the pillar, to the
imposing figure in the top right-hand
corner of the painting.

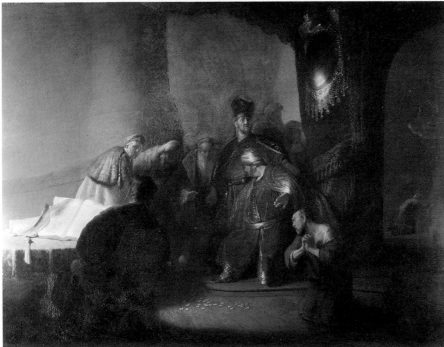

**Judas returning the thirty pieces of
silver**
1629
Oil on panel
76 × 101 cm (30 × 39¾ in)
England: private collection

Rembrandt's earliest masterpiece,
this was enthusiastically singled out
by Constantyn Huygens, secretary to
Frederick Henry, Prince of Orange,
for its narrative power and the
expressiveness of the figures. The
picture is in poor condition in parts,
but it still reveals many superb
passages of painting. The
composition is similar to that of *The
tribute money*, swinging in a slowly
ascending spiral from the great book
open at the table on the left, through
the figures of the priests, to the dark
column with its hangings on the
right. The figure of Judas, and the
arm of the high priest, answer this
curve, turning our gaze toward the
30 pieces of silver on the ground.

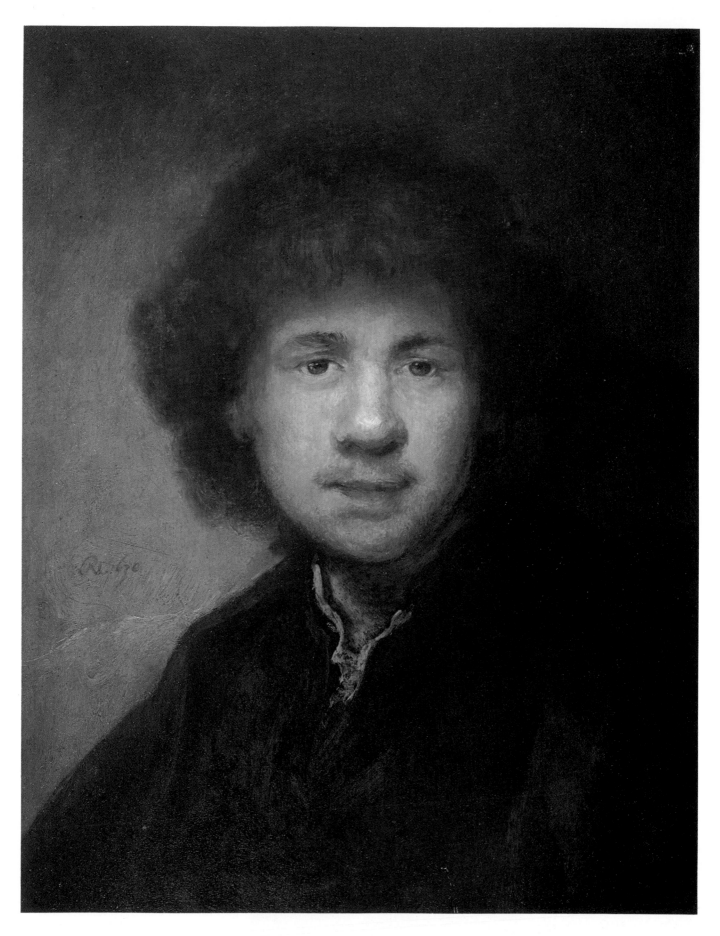

Self-portrait
1630
Oil on panel
49 × 39 cm (19¼ × 15⅜ in)
Aerdenhout (Netherlands): J.H.
Loudon Collection

This self-portrait, which has also suffered, is a straightforward, almost sympathetic treatment of the young artist's features shortly before he moved from Leyden to Amsterdam. It is without the sometimes grotesque grimaces that Rembrandt made in other early self-portraits, and shows a keen-eyed young man, with a large broad nose which he has made no attempt to minimise. The lips are thick and the moustache faint and hardly becoming; there is no hiding the slightly receding chin. One is struck by the honesty of the portrait, by its absence of flattery or swagger (although these attributes are found elsewhere), and by its success in capturing the artist's features with an objectivity and detachment that anticipates the later masterpieces.

The presentation of Jesus in the Temple
1631
Oil on panel
61 × 48 cm (24 × 19 in)
The Hague: Mauritshuis

This is one of the most moving of Rembrandt's biblical pictures, and the apogee of his Leyden style. The scene is painted with exquisite delicacy, the sense of enclosure within a great architectural space being quite remarkable. There has been some doubt about the identity of the tall figure on the left. Is it meant to represent the high priest? A more probable explanation is that Rembrandt has chosen the moment when Anna, the prophetess, comes upon Simeon, Mary, and Joseph in the body of the Temple, not before the altar (Luke II: 21–39). Light is again used in a Baroque manner, illuminating the scene around the Christ child with great effect. Look, for instance, at Anna's white, outstretched hand in the act of blessing, which leads the eye to the face of Jesus; at the same time the lighting is credibly part of the scene and, with the crowd descending the steps on the right, it helps give the 'feel' of an immense religious building.

If Huygens had perceptively recognised Rembrandt's powers as a narrator of stories, it was probably to Lievens that he looked as the restorer of Dutch art to the grand tradition of his beloved Rubens. Rembrandt's small religious paintings would not fit the bill, but his portraits may have been another matter. In 1629 Charles I of England sent Sir Robert Kerr to the Netherlands as his personal representative. The Stadholder, Prince Frederick Henry, presented Kerr with a painting by Lievens, no doubt suggested by Huygens, and this was given to Charles I by Kerr on his return. Kerr was a patron of the poet John Donne, whose works Huygens had translated into Dutch (he had served for a time at the Dutch embassy in London), and it is possible that the latter also recommended to Kerr the two paintings by Rembrandt, a self-portrait with a gold chain (page 21) and the portrait of the artist's 'mother' (page 20), which Kerr is believed to have taken back at the same time and presented to Charles I. Although now separated – one is in the Walker Art Gallery at Liverpool, while the other is at Windsor Castle – the two portraits appeared in the Royal collection shortly afterwards. They are the first paintings by Rembrandt to have been sent abroad, and it is significant that even at this early stage in his career they seem to have been acquired as 'master paintings' rather than as portraits.

The time had come for Rembrandt to move to Amsterdam.

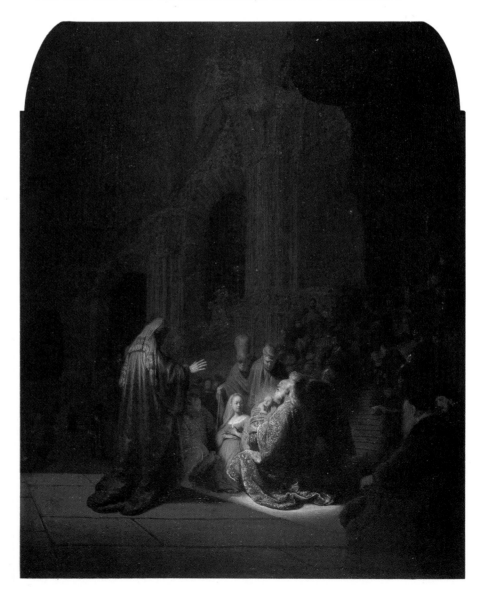

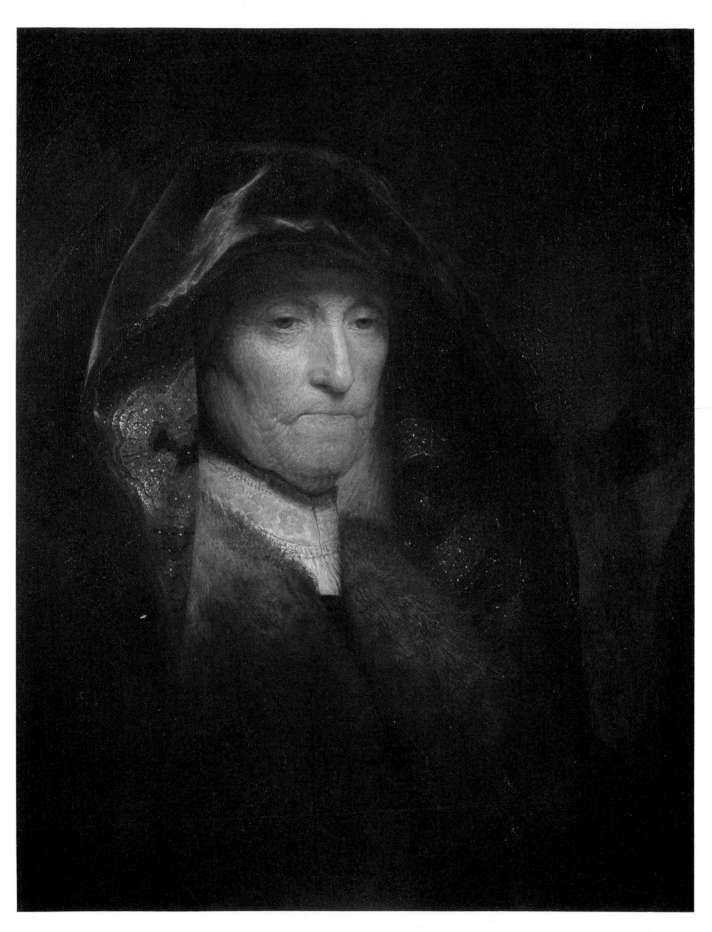

'Rembrandt's mother'
c. 1629
Oil on panel
58.5 × 45 cm (23 × 17¾ in)
Windsor Castle: H.M. The Queen

This superb study of old age in fact probably represents not Rembrandt's mother but an elderly model who appears in other paintings of this period. The rendering of soft, wrinkled skin is unrivalled, while the strong but toothless set of the mouth and the distant look of resignation in the eyes are masterly in their expressiveness. The picture is one of those acquired by Sir Robert Kerr (later Earl of Ancrum) in Holland, probably in 1629, and given by him to Charles I of England sometime before 1633. The Royal Inventory of 1640 refers to it only as 'an old woman', but there is an old label in the back which reads: 'Given to the King by Sir Robert Kerr'. The other Rembrandt acquired by Kerr at this time is the self-portrait now at Liverpool (on the right). X-rays of the Windsor panel show a man's head (upside down) which Rembrandt presumably painted out himself.

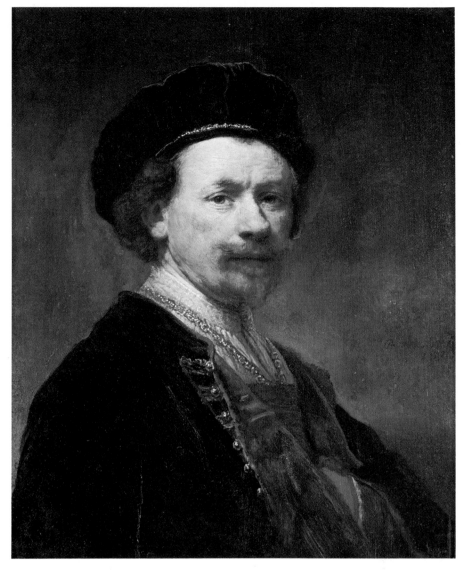

Portrait of the artist as a young man
c. 1629
Oil on panel
69.7 × 57 cm (27½ × 22½ in)
Liverpool: Walker Art Gallery

This portrait was identified in 1935 (when it was still at Penshurst Place, Kent) as the painting in the collection of Charles I listed in the 1640 inventory as follows: 'Item, above my Lo: Ankrom's doore the picture done by Rembrandt being his owne picture done by himself in a black capp and furred habit with a little goulden chaine uppon both his shouldrs. In an oval and square black frame 28 × 23 in. Given to the Kinge by my Lo: Ankrom'. This description fits the Liverpool portrait so precisely that there can be no doubt that it is one of the two Rembrandts acquired by Sir Robert Kerr in Holland, probably in 1629. The other is the 'Rembrandt's mother' at Windsor (on the left). The two pictures were the first Rembrandts to reach England.

The Great Years

Amsterdam in the 1630s was at the beginning of its greatest epoch. All was bustle and building as it established itself as the leading city in the new Dutch state. Rembrandt settled there sometime between March 1631 and July 1632, and the cause of his stay was no doubt the important commission, *Dr Nicolaes Tulp demonstrating the anatomy of the arm* (see pages 12–13), which he completed in 1632. He went to live with an art dealer, Hendrick van Ulenborch, who had a house in the Breestraat where he ran a sort of art school for the children of well-to-do families.

Ulenborch had a young cousin, Saskia, whose father had once been burgomaster of Leeuwarden, in Friesland, on the other side of the Zuider Zee (now the Ijsselmeer). Saskia was an orphan who at the age of 10 had come to live with an older, married sister in Amsterdam. She was small and dumpy with a round face; Rembrandt fell in love with her, perhaps on one of her visits to her cousin's house in the Breestraat. There is a silverpoint drawing of her on prepared paper, wearing a large straw hat and holding a flower, on which Rembrandt wrote: 'This is drawn after my wife, when she was 21 years old, the third day after our betrothal – the 8th June 1633'.

The couple were married in Friesland a year later, the consent of Rembrandt's mother having been obtained by her appearing before a notary in Leyden. Their happiness is evident from the portraits. Rembrandt painted her again and again: in a hat (page 25); with pearls; holding a flower; as Flora (twice: page 28); or seated, slightly amused but still reproachful, on his knee (page 35). For two years they lived with her cousin, before moving to a new house in the Doelenstraat. Rembrandt had become successful and was in a position to lend Ulenborch money. His marriage was advantageous as his wife came from a prosperous professional family. The miller's son must have felt he had made it!

But there was a cloud on the horizon: Saskia's pregnancies. She gave birth to four children, two boys and two girls, but all except the last, Titus, survived for only a few weeks. Rembrandt's drawings at this time are full of studies of women and children, the delicate lines of the pen often combined with great sweeping strokes of the brush.

There was no shortage of portrait commissions for Rembrandt in this period from the fashionable merchant families of Holland and Amsterdam. He took in more pupils: painters such as Jacob Backer, Ferdinand Bol, and Govaert Flinck. The most important commission came from Prince Frederick Henry, the Stadholder, whose gift of two portraits by Rembrandt to Sir Robert Kerr has already been mentioned. Frederick Henry already had in his own collection by 1632 a *Simeon in the Temple*, which Constantyn Huygens had no doubt recommended, but which is touchingly recorded as 'by Rembrandt or Jan Lievens' in the Prince's inventory. Huygens was probably again instrumental in obtaining Rembrandt the commission first for three, and then for five, paintings from the Passion of Christ; the first of which, *The descent from the Cross* (see page 27), was finished in 1633 and the last, *The Resurrection*, in 1639.

The seven surviving letters from Rembrandt to Huygens are solely concerned with this commission, and we know from them that Huygens insisted on inspecting each painting at his own house before it was delivered to the Stadholder's palace in the Old Court at The Hague. The style of the five paintings owes much to Huygens' known liking for Flemish art, and one of them, *The descent from the Cross*, is an obvious attempt by Rembrandt to pay homage to Rubens' great altarpiece in Antwerp cathedral.

On 1 May 1639 Rembrandt and Saskia moved into a grand house on the Breestraat, next door to her cousin Ulenborch's house where they had spent the first years of their marriage. The house today is much altered,

Scholar in a room with a winding stair
1632 or 1633
Oil on panel
29 × 33 cm (11¾ × 13 in)
Paris: Louvre

This small painting shows again Rembrandt's interest in a spiralling

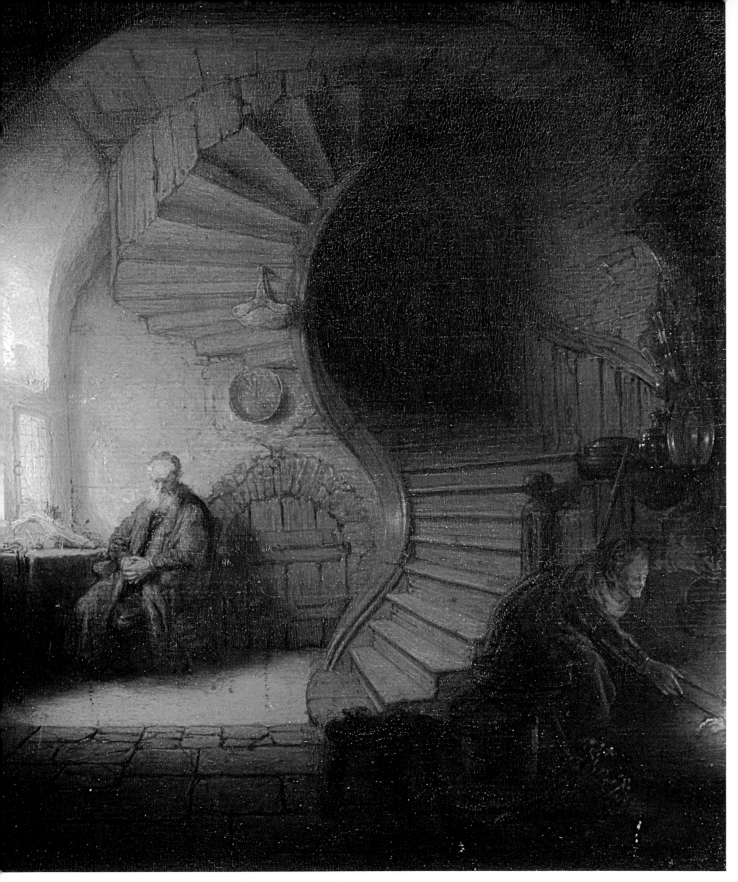

staircase as a compositional device. Here it is the actual subject of the painting; the small figures of the scholar and the servant stoking the fire fit snugly into the spaces left by the stairway, which itself is framed by the arch of light produced by the window. A vertical accent is provided by the semi-circular door in the centre and by the baskets hanging from the wall and from the treads of the stair. The picture is typical of the intimate tenderness of Rembrandt's style in the transitional Leyden/Amsterdam years. There is a companion-piece (also in the Louvre) which used to be ascribed to Rembrandt but is now regarded as the work of a pupil, probably Salomon de Koninck. Members of Rembrandt's studio frequently made paintings in the same style so that they could form matching pairs.

but is preserved as a Rembrandt museum. It lies in what is now a poor quarter of Amsterdam, but in Rembrandt's day the district was prosperous and the price of the house was more than he could afford. Rembrandt wrote to Huygens pressing for the last payment on the Stadholder's commission; then he reduced his hoped-for price on condition he was paid for 'the two ebony frames and the crate, which is 44 gilders in all'. Finally, on 17 February, Huygens authorized payment of 1,244 gilders, including the cost of the frames.

The spring of 1639, however, marks the end of their association, and the beginning of Rembrandt's financial worries. He had over-reached himself. His style of living and his avid collecting of paintings and objects to further his work had been made possible by Saskia's dowry and his own success as a fashionable portrait painter. Now Saskia had become weakened by successive pregnancies, and a change began to come over Rembrandt's art. In spite of, or perhaps because of, his attempt to emulate the courtly art so beloved by Huygens and Prince Frederick Henry, Rembrandt at 34 was becoming a more serious and individual painter. The self-portrait of that year (see page 13) shows a more mature man – one who was aware of the golden age of Venetian painting and of his own relationship to the tradition of European art. Rembrandt the rebel, the innovator, was about to develop his own original contribution to that tradition, steeped in the past but not confined by the narrow boundaries of contemporary taste.

In 1640 Rembrandt's mother died, to be followed early the following year by Rembrandt's and Saskia's third daughter, Titia. In September 1641 their son Titus was born. Saskia, however, was now desperately ill; she probably never recovered fully from giving birth to Titus, and on 14 June 1642 she died and was buried in the Oude Kerk in Amsterdam. Shortly before her death Saskia had made a will which, although well intentioned, was to cause Rembrandt further hardship. The joint estate, according to common law, was divided in two: Rembrandt retained his half and Saskia's portion was left to the infant son Titus, although Rembrandt was granted the use and enjoyment of it until Titus came of age or married. Should Rembrandt remarry, however, Saskia's half of the estate would pass immediately to her widowed sister and her other relatives.

Saskia's illness and death, and what was long assumed to be the poor reception accorded Rembrandt's masterpiece *The militia company of Captain Frans Banning Cocq*, popularly known as 'The night watch' (see title page), which he painted the same year, often used to be given as the cause of a dramatic change in Rembrandt's art and fortunes at this time. In fact, greatly as he had loved Saskia, the development of his art continued unabated during the later years of their marriage, while 'The night watch' had a far from unfavourable reception. The change, for change there was, had begun before Saskia's health broke down, and 'The night watch' was much admired and famous in his lifetime. The picture represents a company of the Civic Guard marching out under the command of Captain Frans Banning Cocq in the *daytime* – the popular title is a misnomer given to the painting in the 19th century, when it had darkened with age. Banning Cocq was a wealthy gentleman, and by the 1640s the activities of such militia companies had more than an element of 'playing at soldiers'. He and his brother officers of the company would have commissioned the picture as a large group portrait, to which each musketeer contributed part of the fee. Unlike Frans Hals in Haarlem, who painted such portraits with a lively blend of subtlety and flattery, Rembrandt adopted the revolutionary solution of a dramatic call to arms. He may have been influenced in this by contemporary dramas, such as a play about the Dutch hero Gysbrecht van Amstel. Many figures in the painting can be identified: Banning Cocq, leading the march, is giving orders to his lieutenant, Willem van Ruytenburgh, dressed in yellow; at the back the colours of Amsterdam are held aloft by Jan Cornelis Visscher.

Rembrandt's immediate troubles were to come from another source. He had employed a nurse to look after Titus, a trumpeter's widow called

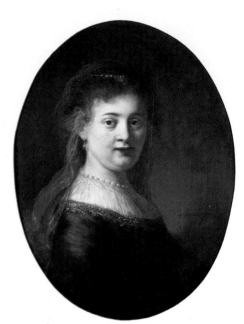

Portrait of Saskia
1633
66.5 × 49.5 cm ($26\frac{1}{4}$ × $19\frac{1}{2}$ in)
Amsterdam: Rijksmuseum

A charming portrait of Saskia van Ulenborch, the niece of the art dealer Hendrick van Ulenborch, at the age of 21 in 1633 – the year of her engagement to Rembrandt. This portrait of the young bride-to-be has all the loving tenderness one could expect, but also reveals what must have appealed about her to Rembrandt: the lively features, the steady mouth – and that hint of the affluence of a higher social class in the pearl necklace and eardrop, the richness of the gown, and the whiteness of the ruched linen.

Saskia in a red hat
1633/4
Oil on panel
99.5 × 78.5 cm ($39\frac{1}{4}$ × 31 in)
Kassel: Staatliche Kunstsammlungen, Gemäldegalerie

This carefully executed portrait of Saskia probably depicts her in the year of her marriage. It is hardly a marriage portrait, however, and seems to have been posed by Rembrandt to show off his enormous skill with textures. This was the portrait Rembrandt sold to Jan Six in 1652, nearly 19 years after it was painted. Its history can be traced all the way from the artist's studio to its location today. It appeared in the sales of the Six collection (1702 and 1734), entered the Valerius de Roever collection, and in 1750 was acquired by the Landgraf Wilhelm VIII von Hessen-Kassel.

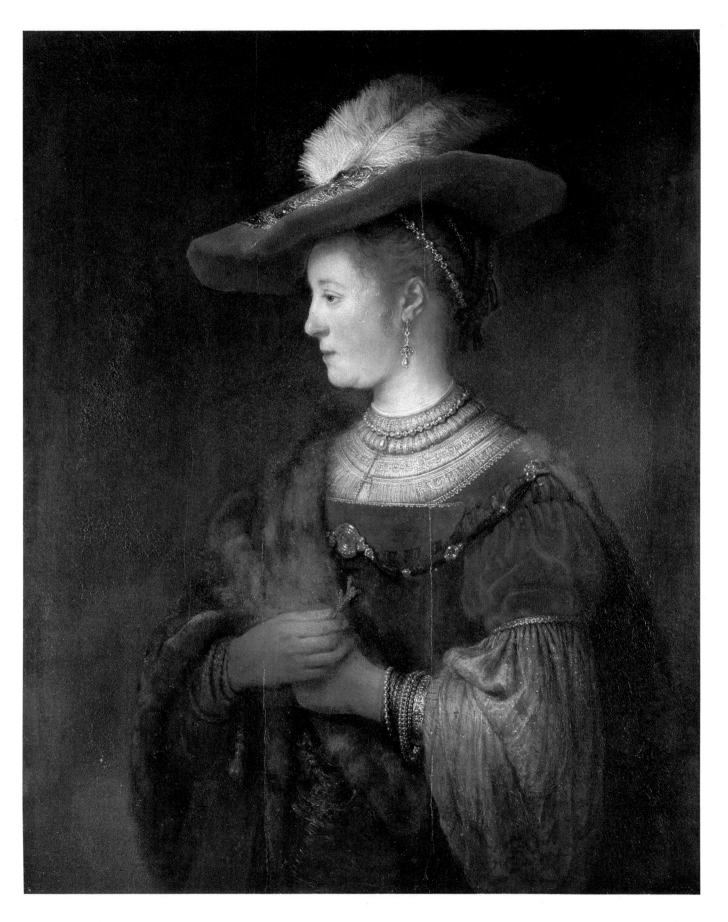

The raising of the Cross
1633
Oil on canvas
96 × 72 cm (37⅞ × 28⅜ in)
Munich: Alte Pinakothek

This canvas and *The descent from
the Cross* (facing page) were the first
paintings completed for the series of
scenes from the Passion bought
through Constantyn Huygens for the
Stadholder, Prince Frederick Henry.
Rembrandt's only surviving letters,
written to Huygens, the Stadholder's
secretary, relate to this commission;
the first letter, which bears a date of
1636, is thought to imply that
Rembrandt had started painting
these two paintings *before* they were
set aside for Huygens: '. . . very
diligently engaged in completing as
quickly as possible the three Passion
pictures, which His Excellency
himself commissioned me to do: an
Entombment, a Resurrection, and an
Ascension of Christ. These are
companion pictures to Christ's
Elevation and Descent from the
Cross'. The Elevation (that is, *The
raising of the Cross*) is loosely based
on Rubens' famous painting of the
same subject in Antwerp cathedral;
but Rembrandt has modelled the
figure in the blue beret in the centre
on his own self-portrait of 1633.

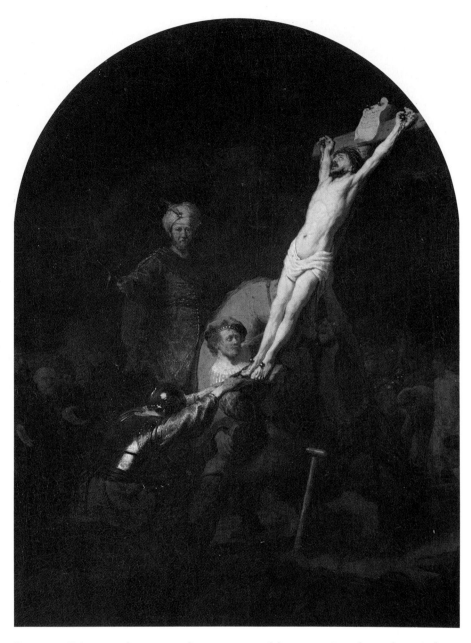

Geertge Dircx, who soon became troublesome. Rembrandt tried to
placate her with presents, but she eventually sued him for breach of
promise, claiming one of the presents was a ring. Rembrandt was hardly
in a position to remarry, because of Saskia's will, and the upshot was that
he had to pay Geertge 200 gilders a year for the rest of her life.

Rembrandt's household in the large house in the Breestraat also
included a number of servants. It was one of these, Hendrickje Stoffels, a
soldier's daughter, who became in time Titus's nurse and Rembrandt's
common-law wife (she is first documented in his household on 1 October
1649). Her placid temperament and humble origins, so unlike those of the
sprightly Saskia, suited Rembrandt admirably. She appears repeatedly as
the model and inspiration of his art after 1650, and even when one cannot
be certain of her identity from the features – for no formal portrait exists –
there is a sense of her presence in some of his greatest paintings. She lived
with Rembrandt until her death in 1663. She gave him a daughter,
Cornelia, in 1654; on four occasions that year she was summoned to appear
before the Council of the Reformed Church, but only on the last occasion
did she appear in person to receive her admonishment for living openly
with the painter as his mistress. To appease the elders she had their
daughter baptised on 30 October that year.

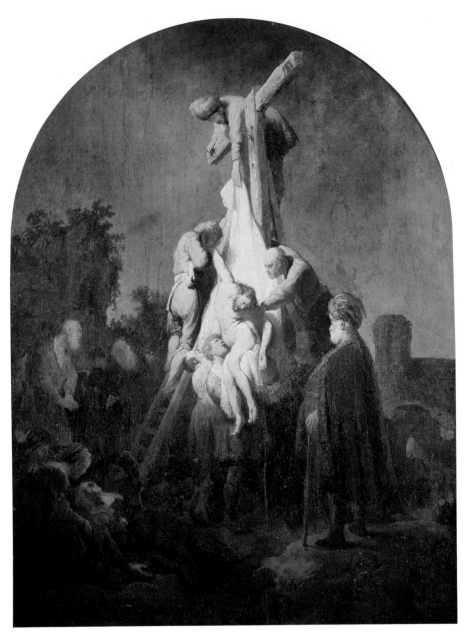

The descent from the Cross
1633
Oil on panel
89.5 × 65 cm ($35\frac{1}{4}$ × $25\frac{5}{8}$ in)
Munich: Alte Pinakothek

As in its companion-piece (opposite) Rembrandt has included a self-portrait in this picture – the man in blue, half-way up the ladder holding Christ's arm; it is based on a self-portrait of 1629. The picture is derived from another painting by Rubens, also in Antwerp cathedral, but the grouping of the figures, the tonality, and the effect of a spotlight on the circle around the tortured figure of Christ are entirely Rembrandt's own. He may also have been aware of the treatment of the subject by the Italian painter Jacopo Bassano (1517–92), a copy of whose painting was in a private collection at Antwerp. The series of Passion pictures painted for the Stadholder are mentioned in the 1667 catalogue of the royal palace at The Hague, but by 1719 they are listed in the catalogue of the Düsseldorf gallery in Germany. In the 18th century they were temporarily moved to Mannheim, and they were finally transferred from Düsseldorf to Munich in 1806.

In spite of his troubles the 1640s and early 1650s were Rembrandt's greatest years as an artist. It is true that the fashionable world largely deserted him, turning instead to his former pupils, Bol and Flinck; but he still had influential patrons and friends: Frederick Henry, the Stadholder, commissioned two further subjects from him in 1646, a *Nativity* and a *Circumcision*, for which he paid 2,400 guilders. But henceforward Rembrandt's friends were to be increasingly drawn from the professional classes: doctors, poets, printers, and fellow painters. Chief amongst these was Jan Six, a dyer and silk merchant of Huguenot descent, whose mother Rembrandt had painted in 1641.

The two men seem to have had much in common, although Jan Six was 12 years younger than Rembrandt. Many of Rembrandt's landscape drawings of this period may have been done while he was staying at Six's country estate on the Diemerdyke, outside Amsterdam. Six was also a poet and a collector of Dutch and Italian art; he owned paintings by Rembrandt, one of which was a portrait of Saskia (see page 25), and Rembrandt provided an etched frontispiece to his long poem *Medea*. But Six became increasingly classical in his artistic taste, and also ambitious for high office in the state. In 1652 he gave up active direction of his business concerns, and in 1655 he married the daughter of the influential

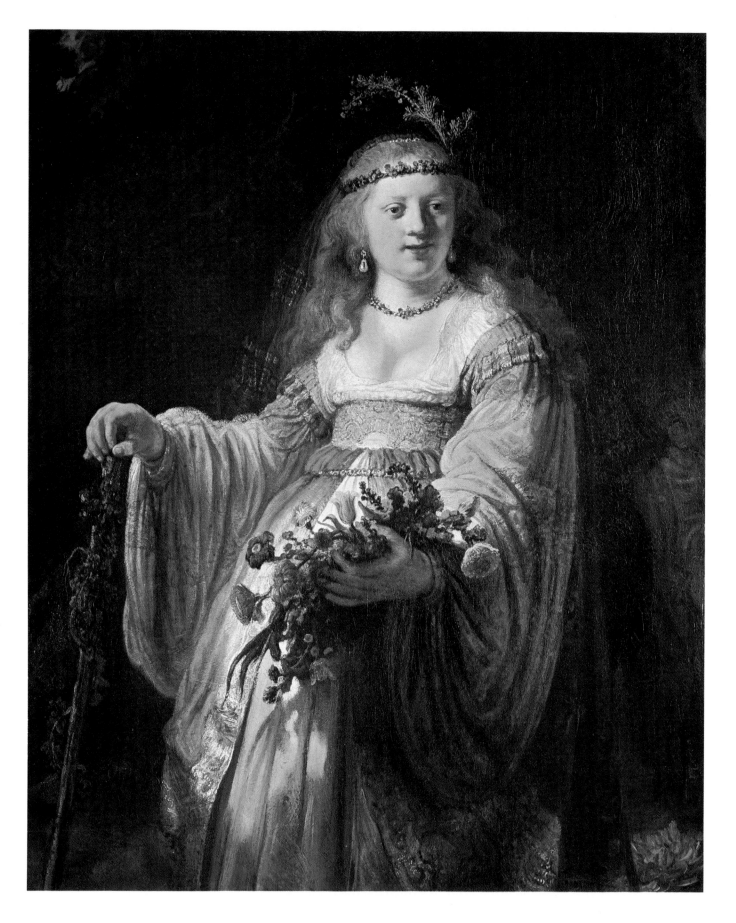

Portrait of an eighty-three-year-old woman
1634
Oil on oval panel
68.7 × 53.8 cm (27 × 21$\frac{1}{8}$ in)
London: National Gallery

This powerful portrait of an old woman is one of the finest and best preserved of all Rembrandt's female portraits of the 1630s. A drawing of the same model by Jan Stolker (1724–85) in the British Museum identifies her as Françoise van Wassenhove, the widow of a Remonstrant preacher. Stolker's drawing was made not from this picture but from a drawing by Hendrick van Limborch (1681–1759), which may or may not have been taken from Rembrandt's painting. Whatever her identity, this old woman inspired in Rembrandt a masterly study of old age that transcends the individual and has a universal significance as an image of dignified if care-worn maturity. The slope of the shoulders is subtle, and Rembrandt has used the head-dress and ruff to illumine the face with its still-keen, downcast eyes.

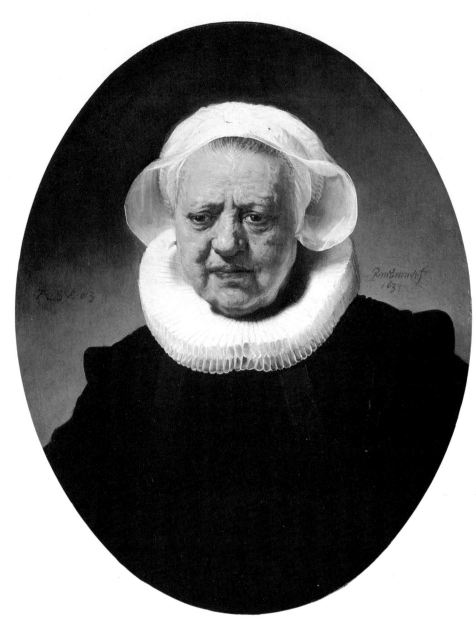

Saskia as Flora
1635
Oil on canvas
123.5 × 97.5 cm (48$\frac{5}{8}$ × 38$\frac{3}{8}$ in)
London: National Gallery

Rembrandt had already painted his young wife the previous year (1634) as Flora, the Roman goddess of flowers, in a portrait now in the Hermitage at Leningrad. The National Gallery picture may in fact show Saskia not as Flora but in the guise of an Arcadian shepherdess. Whatever the ostensible subject, Rembrandt once again lavished his utmost care and skill on the rendering of the richness of hair and skin, flowers, and voluminous drapery. This is an altogether sumptuous portrait, symbolic perhaps of Rembrandt's greater sense of security induced by his young wife's substantial dowry.

Dr Nicolaes Tulp. Six had lent Rembrandt money, and probably felt his career might be embarrassed by his friend's financial problems. Whatever the cause, their friendship cooled in the mid-1650s, and Rembrandt's magnificent portrait of him (see page 47) has an enigmatic finality about it, as if Six's drawing on of his glove signalled, regretfully, the end of an epoch in the affairs of both men.

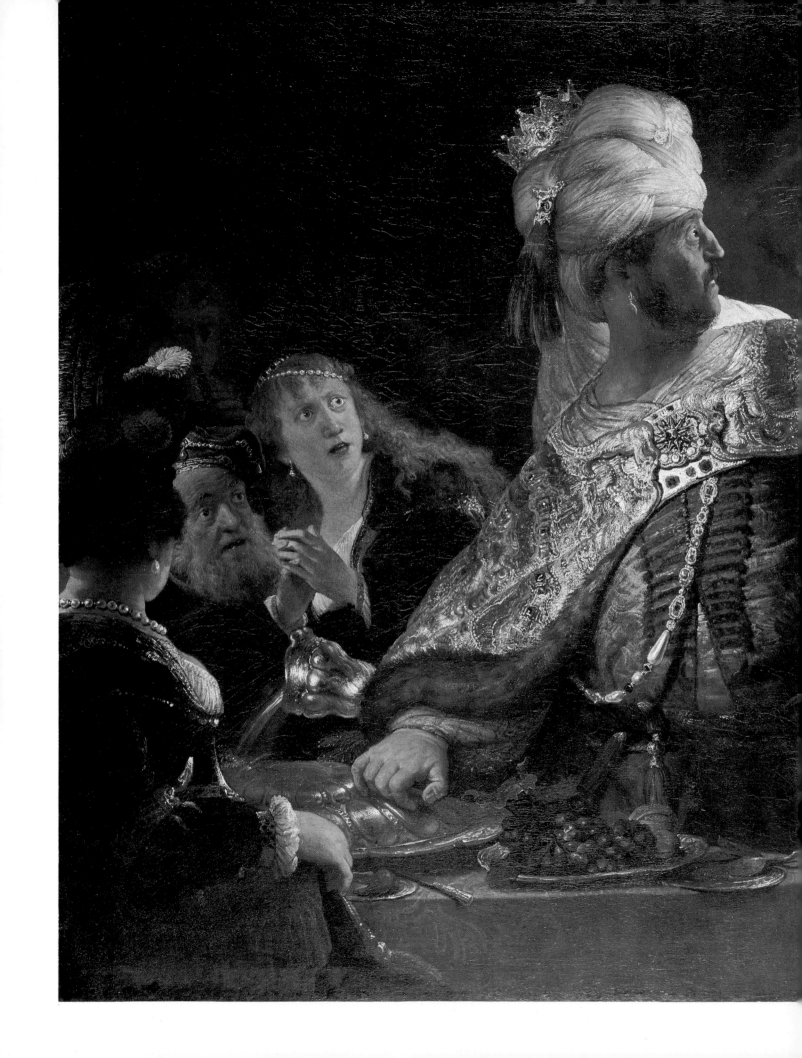

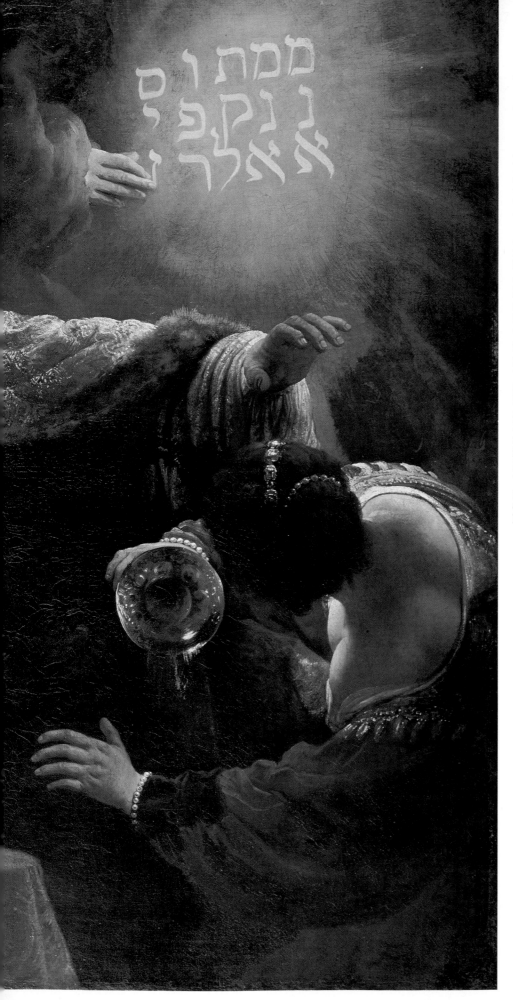

The feast of Belshazzar
c. 1635
Oil on canvas
167 × 209.5 cm (65¾ × 82½ in)
London: National Gallery

Most scholars place this impressive painting in the mid-1630s, although Kenneth Clark has asserted it is earlier than that of Dr Tulp's anatomy lesson (1632). The painting shows the moment when Belshazzar sees the writing on the wall – an inscription in Hebrew on which Rembrandt may have obtained advice from his friend Menasseh ben Israel. The figure of Belshazzar is obviously related to other studies of turbaned 'orientals' that Rembrandt was painting at that time (see page 9), while the figures on the left, particularly the old man and the girl with pearls in her hair, are realistically observed. The foreshortened female figure on the right, however (as Kenneth Clark has also pointed out), is 'too obviously a creation of art': she is in fact derived from the girl helping Europa on to the bull in Paolo Veronese's painting in the Doge's palace, Venice – another hidden example of Rembrandt's debt to Italian Renaissance painting.

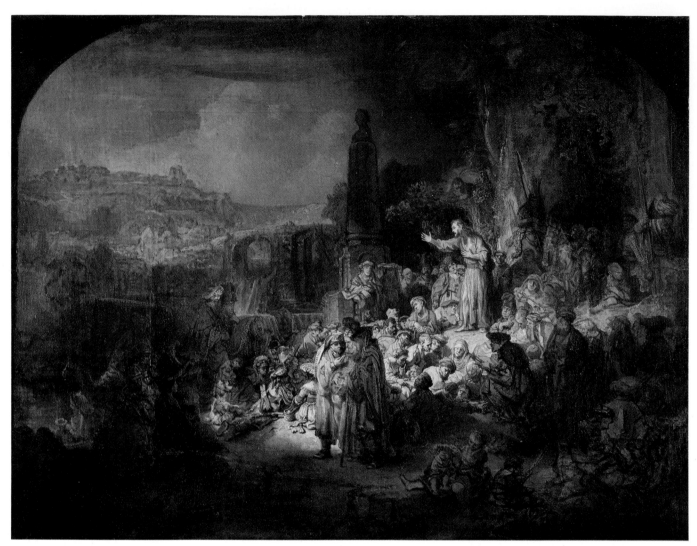

St John the Baptist preaching
c. 1635/6
Oil on canvas laid on panel
62 × 80 cm (24½ × 31½ in)
West Berlin: Staatliche Museen
Preussischer Kulturbesitz,
Gemäldegalerie

This painting is a *grisaille* – that is,
it is painted in tones of a single
colour. It has something of the
quality of Rembrandt's etchings in
the crowded massing of the figures,
the graphic detail, and of course the
absence of colour; it is really a
drawing in paint. Its exact purpose
is not known, and Rembrandt
enlarged the small panel to its
present size, perhaps in the 1650s,
shortly before Jan Six acquired the
painting. There is a pen-and-brown-
wash drawing (about 1655) of the
picture in the Louvre, with the
design for a frame around it, and on
the back another sketch of a frame.
It is tempting to suppose that these
were the product of a discussion
between Six and Rembrandt about a
suitable design for the frame.

The Ascension of Christ
1636
Oil on canvas
92.5 × 68.5 cm (36½ × 27 in)
Munich: Alte Pinakothek

The *Ascension* was the third picture
to be completed in the series of
Passion paintings Rembrandt did for
the Stadholder, Frederick Henry. We
know it was the third of the five to
be finished because Rembrandt refers
to it in his letter of 1636 to Huygens:
'Of these three aforementioned
pictures, one has been completed,
namely Christ ascending to Heaven,
and the other two are more than
half done'. X-ray photographs have
been taken of the picture, which
show that Rembrandt originally
painted God the Father above
Christ's head. Traditionally this was
the way of treating the Assumption
of the Virgin, who is also usually
supported by clouds and angels, as
here. Rembrandt may have had in
mind an engraving of Titian's great
altarpiece in the church of Santa
Maria Gloriosa dei Frari in Venice.

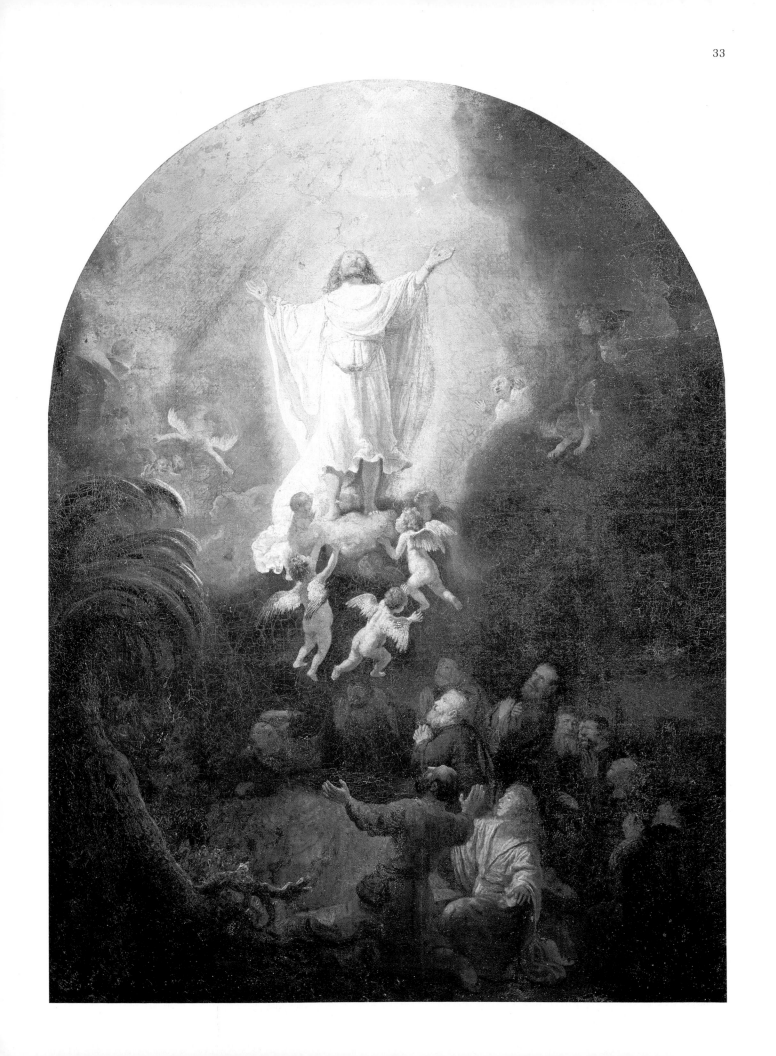

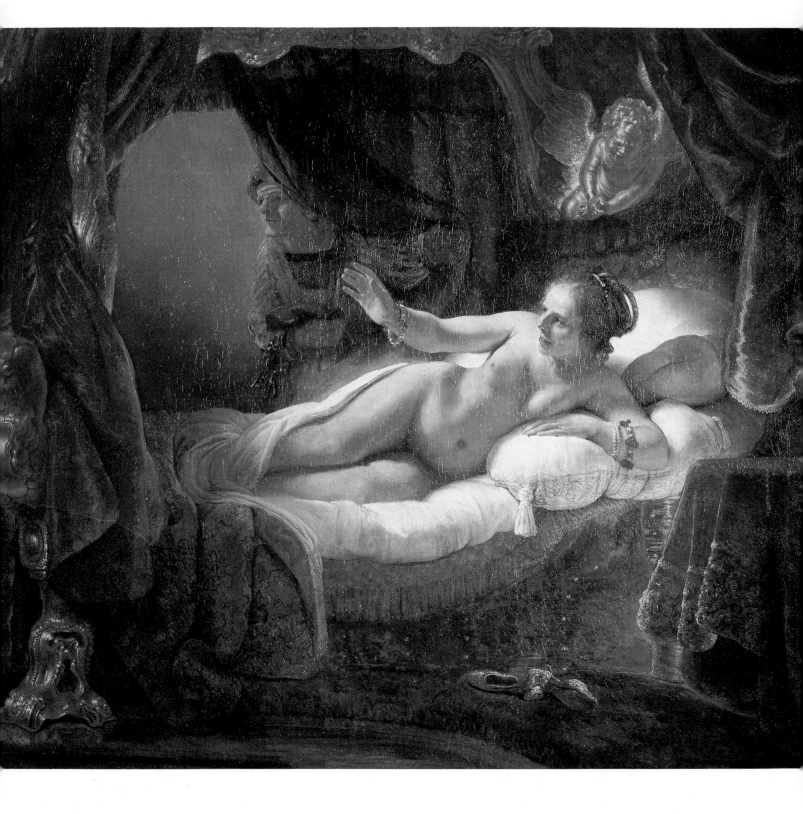

Danaë
1636
Oil on canvas
185 × 203 cm (72$\frac{7}{8}$ × 80 in)
Leningrad: Hermitage Museum

One of the most sexually explicit
great paintings in the history of art:
Danaë greets her lover, disguised as
a shower of gold, with an
unequivocal gesture, while the
golden light caresses and explores
her soft body. Part of the
effectiveness of the painting derives
from the contrast between the 'hard'
Baroque style of the bed and its
hangings, and the soft, life-like flesh
of the figure, typical of Rembrandt's
later style. It is now thought that the
figure of Danaë is a re-working,
probably done in the early 1650s, of
a painting of 1636. X-ray
photographs seem to confirm this,
and show that the position of the
outstretched arm is a later
improvement. Rembrandt once again
had in mind Venetian models for the
nude – particularly Titian's *Venus*
(in the Uffizi gallery, Florence) – but
has transmuted those languorous
figures into pulsating flesh and
blood. The painting is a hymn to
human sensuality.

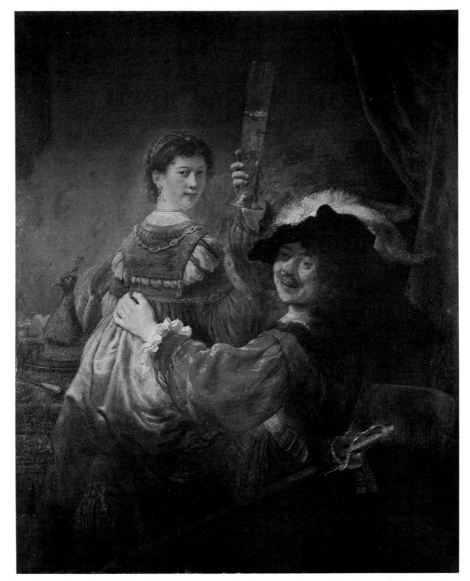

**Rembrandt and Saskia ('The
Prodigal Son in the tavern'?)**
c. 1636
Oil on canvas
161 × 131 cm (63$\frac{1}{4}$ × 51$\frac{1}{2}$ in)
Dresden: Staatliche
Kunstsammlungen, Gemäldegalerie

There is some uncertainty whether
this painting represents Saskia with
Rembrandt in boisterous mood (as
used to be thought), or a moral
subject, such as The Prodigal Son.
Even if it was not intended as an
unconventional portrait of the artist
and his wife, the two likenesses
cannot be denied. Rembrandt was
for ever playing roles in his self-
portraits, and this picture may have
owed its origin to the tavern scenes,
painted in contrasting lights and
darks, by the followers in Utrecht of
the Italian painter Caravaggio
(1573–1610). It is difficult, however,
to see a common tavern in the rich
furnishings of the table, the tall
glass, and the bejewelled female
figure. Psychologically, the slightly
reproachful look on the girl's face
and the affectionate gesture of the
man have too much of what we
know of Saskia and Rembrandt for
them to be entirely ruled out as
subjects as well as models.

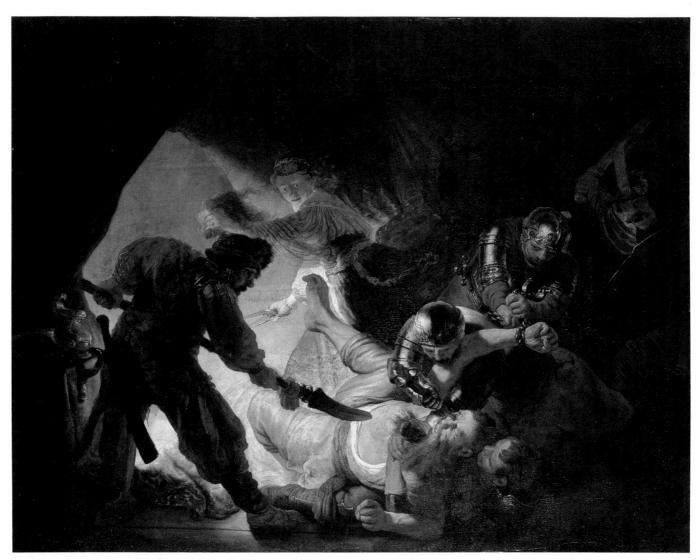

The blinding of Samson
1636
Oil on canvas
236 × 302 cm (93 × 119 in)
Frankfurt: Städelsches Kunstinstitut

This painting, once even larger than
it is now, was the work Rembrandt
presented in 1639 to Constantyn
Huygens, who had acted as the go-
between in the commission from the
Stadholder. Huygens at first did not
want to accept the painting, but
Rembrandt persisted: 'I cordially
remain obliged to you to repay your
lordship with service and friendship.
Because I wish to do this, I am
sending this accompanying canvas,
against my lord's wishes. . . .'
Rembrandt added a postscript
urging Huygens to hang the picture
in a strong light in order to show it
at its best. It might be thought that
the subject was an unnecessarily
bloodthirsty one for a gift, but
Rembrandt knew his man and, in
particular, his liking for the more
violent canvases of Rubens.

Susanna surprised by the elders
1637
Oil on panel
47.5 × 39 cm (18¾ × 15¼ in)
The Hague: Mauritshuis

This small study, typical of
Rembrandt's style at this date, was
used as the first version of the larger
painting in Berlin (see pages 42–3).
In the study, Susanna's vulnerable
body, the feet not quite in her
slippers, is recoiling instinctively, as
if hearing some movement in the
bushes. Her apprehensive look is
directed at the spectator, giving the
picture a disturbing immediacy, and
casts the onlooker in the role of the
peeping elders. Her body is not
beautiful, but it is frankly observed,
giving it a feeling of compelling
realism. The long curve of the back
is admirably placed in relation to the
pile of clothes, the stone ornamental
ledge, and the distant architectural
landscape, which gives the
composition a most satisfying
abstract appeal.

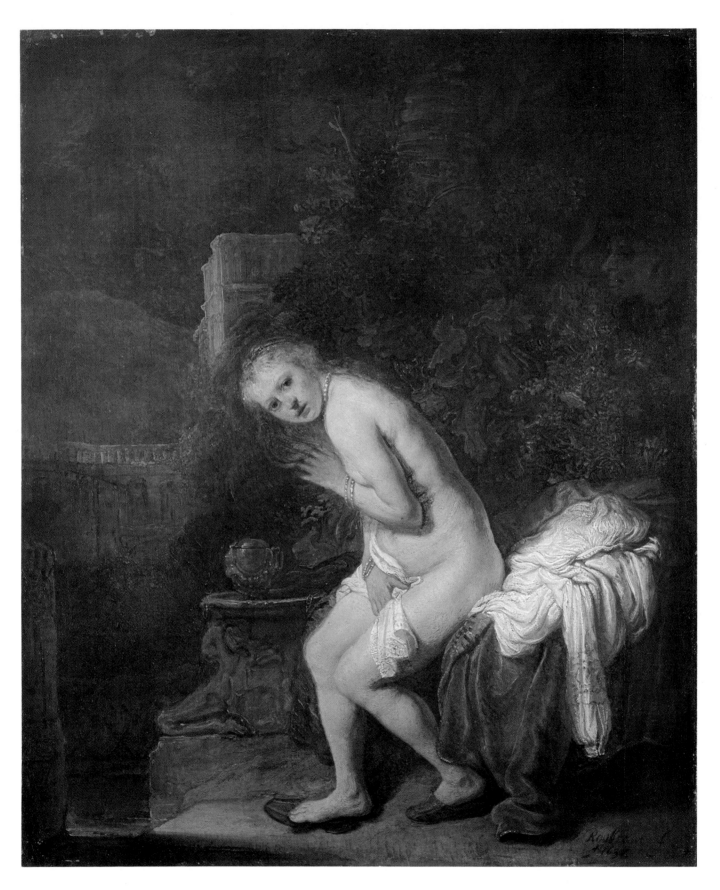

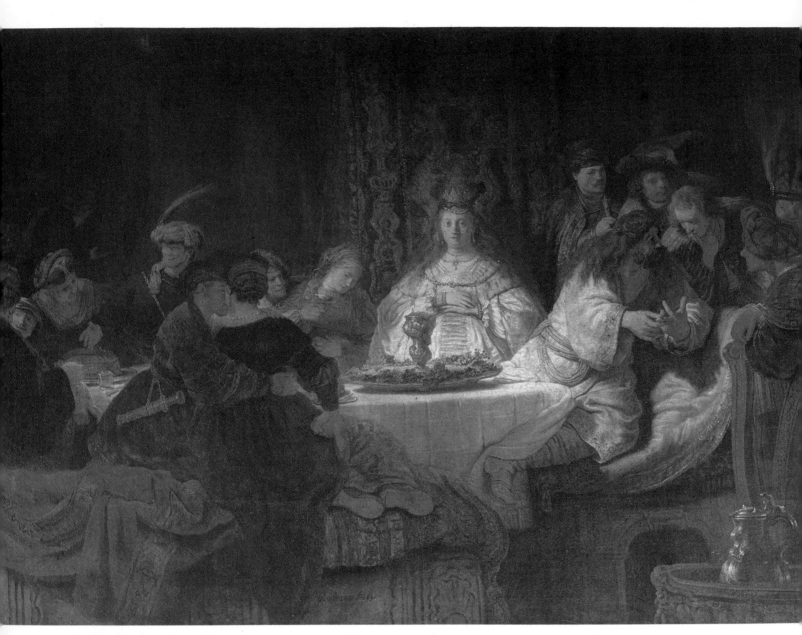

Samson posing the riddle to the wedding guests
1638
Oil on canvas
126.5 × 175.5 cm (49½ × 69 in)
Dresden: Staatliche
Kunstsammlungen, Gemäldegalerie

This mysterious painting, rather
sketchy in execution, concentrates
the centre of interest on the extreme
right of the canvas where Samson,
with gesticulating fingers, poses the
riddle to his guests. The faces in
this group, so distinct from the
amorous couples seated at the table,
have the appearance of real
portraits; Rembrandt's self-portrait
has been 'recognised' both in the
man with the flute and in the face
with a feathered beret. The painting
was singled out for praise by Philips
Angel speaking in Leyden on St

Luke's day in 1641: 'This flowering
of personal invention derived from a
careful reading of the said story, and
by thoroughly thinking it over'.
Rembrandt's exhaustive study of the
Bible is well known, but the
composition also borrows something
from drawings Rembrandt made of
Leonardo's *Last Supper* – hence the
curiously Christ-like figure of the
resplendent bride.

The reconciliation of David and Absalom
1642
Oil on panel
73 × 61.5 cm (28¾ × 24¼ in)
Leningrad: Hermitage Museum

Although for long known by the
above title, the painting is now
thought by some scholars to

represent the parting of David and
Jonathan. It is difficult to decide
between the two schools of thought,
but the dignified, fatherly tenderness
of the turbaned figure towards the
beautiful youth with the flowing
blond hair is perhaps sufficient to
justify retention of the old title.
Painted in the same year as '*The
night watch*' (see title page), the
painting has none of the bravura of
that masterpiece, but harks back to
the artist's style of the late 1630s.
Rembrandt's rendering of the sky
and the architectural landscape is
masterly, and seems somehow to
echo the emotions of the two actors
in the drama.

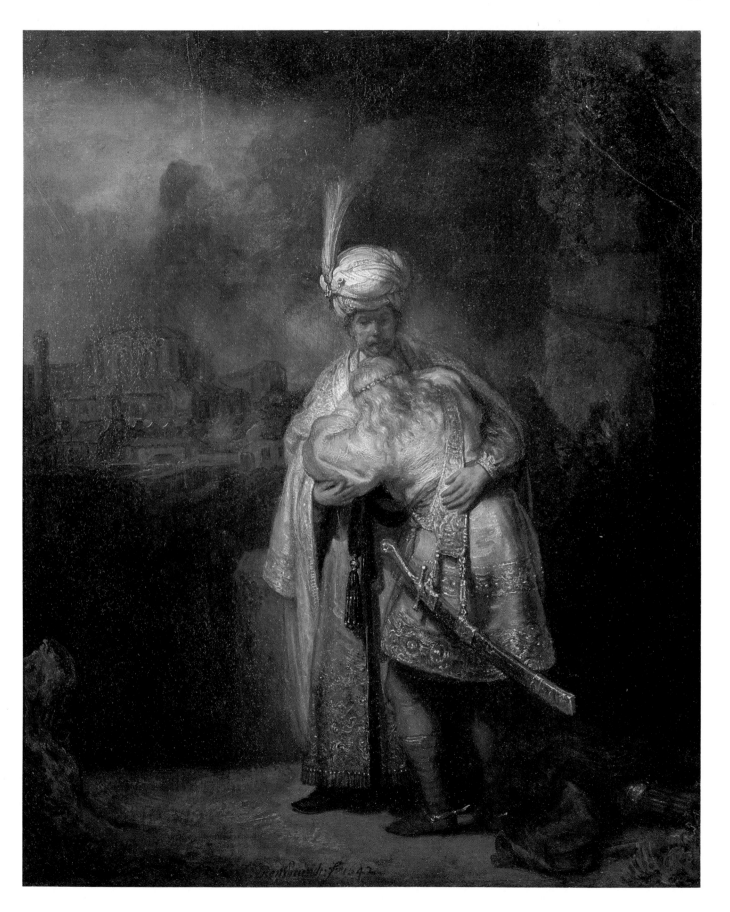

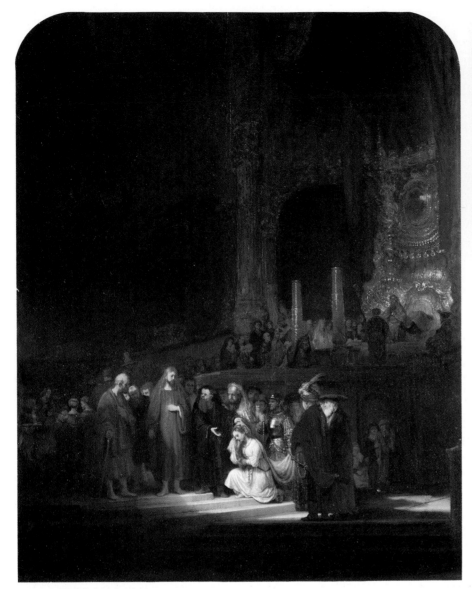

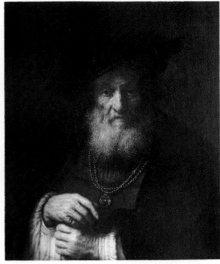

Christ and the woman taken in adultery
1644
Oil on panel
83.8 × 64.5 cm (33 × 25¾ in)
London: National Gallery

The subject is taken from St John's Gospel, VIII:3 – the moment when the woman is brought before Christ in the Temple. It may have had a particular relevance to Rembrandt at this time, although it was painted earlier than the first documented reference to Hendrickje Stoffels in his household. In some ways the picture is a return to Rembrandt's style of the 1630s, and in its composition, detailed finish, and elaborate background is reminiscent of *The presentation of Jesus in the Temple* of 1631 (page 19). The characterization, however, is more secure and the sumptuous architectural background is handled with consummate ease, allowing a subordinate scene to be realised beyond the fluted columns without detracting from the main subject of the painting.

An old man in rich costume
1643
Oil on panel
72.5 × 58.5 cm (29 × 23½ in)
Woburn Abbey: Duke of Bedford Collection

This painting of an elderly Jew is one of Rembrandt's finest portraits of this type, anticipating the simplicity of his own late self-portraits. The figure of the old man forms a classical pyramid against a plain, dark background; his broad cap and white beard forming another inverted pyramid above. The face shows a mixture of shrewdness and compassion. The hands, placed asymmetrically to the left in the composition, seem to echo this combination: in spite of the puckers in the aging skin, the lower hand firmly and resolutely grasps the staff, while the upper one is resting with gentle, almost elegant articulation on top of the knob.

Hendrickje Stoffels in bed
1645–50
Oil on canvas
80 × 66.5 cm (32 × 26½ in)
Edinburgh: National Gallery of Scotland

The signature date (at bottom left, below the pillow) used to be read as 1641, but the picture must be placed on stylistic grounds in the late 1640s. It is not entirely established that the model is Hendrickje Stoffels, and she certainly looks older than 23 – which would have been Hendrickje's age in 1649. It may be that she is Geertge Dircx, who preceded Hendrickje as Rembrandt's common-law wife and was Titus's nurse at this period. Whatever the sitter's identity, the picture is not a true portrait but rather a dramatic incident in which the personality of the model is retained; it shows a growing warmth and human sympathy in Rembrandt's art. The plain, well-covered woman lifts the rich, red hanging of the bed, her attention attracted by some incident in the room. There is neither overt nudity nor false modesty in the treatment of the woman: Rembrandt has accepted the model as she is and has lavished his painterly skills on the sensuous modelling of her bare shoulders and arm, and the plump white pillow.

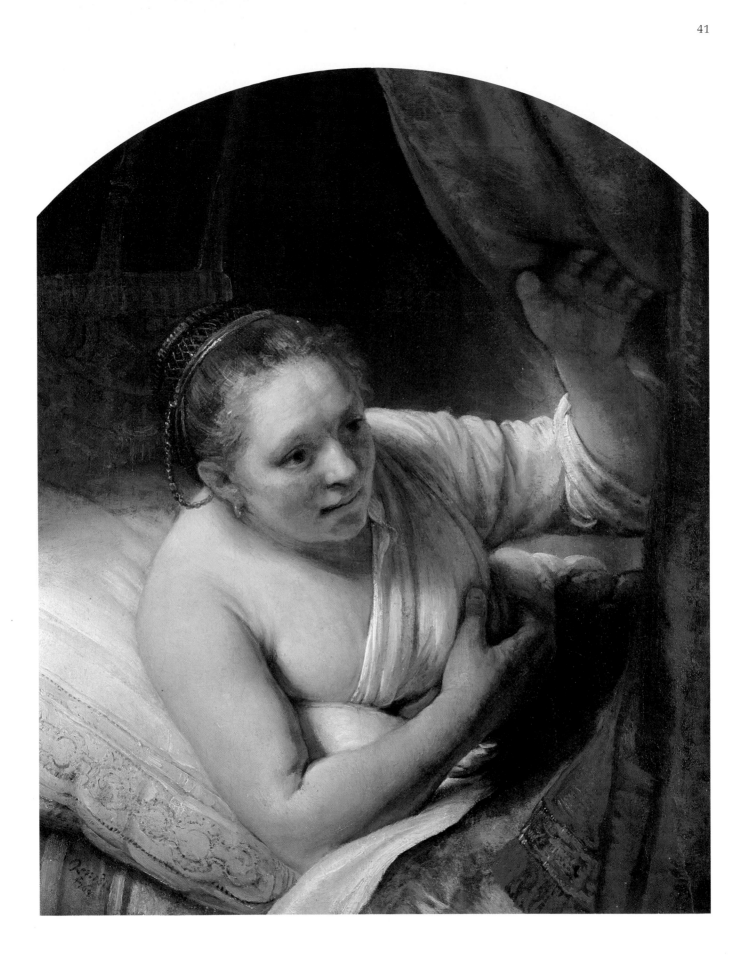

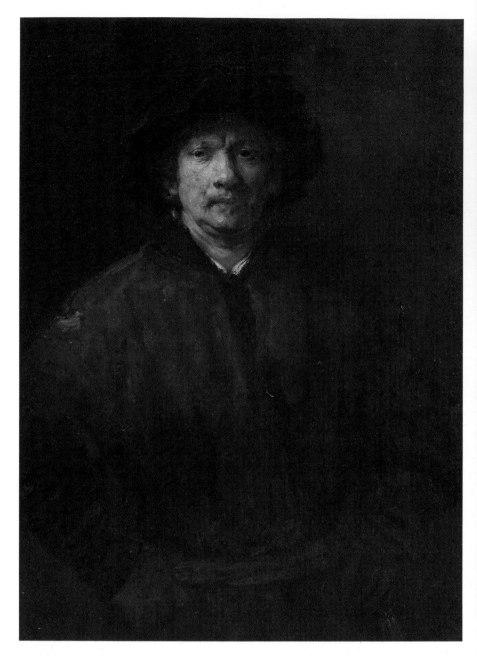

Self-portrait
1652
Oil on canvas
112 × 81.5 cm (44 × 32 in)
Vienna: Kunsthistorisches Museum,
Gemäldegalerie

One of the first of the great self-portraits of Rembrandt's later years. The proud pose is related to Rembrandt's drawing in the Rembrandthuis in Amsterdam in which he is seen, short in stature, full length. The painter stands facing the easel (the spectator?) dressed in his working clothes, his hands thrust defiantly into the twisted belt round his waist. His eyes are slightly narrowed, and the brow is puckered as he scrutinises his own face (and us). The mouth is gently pursed, and there is more than a hint of a double chin, but the moustache is trim and fashionable. Rembrandt is 46 years old, at the height of his powers as a painter and beginning that long journey of proud, melancholy introspection that was to produce masterpieces in this genre until the end of his life.

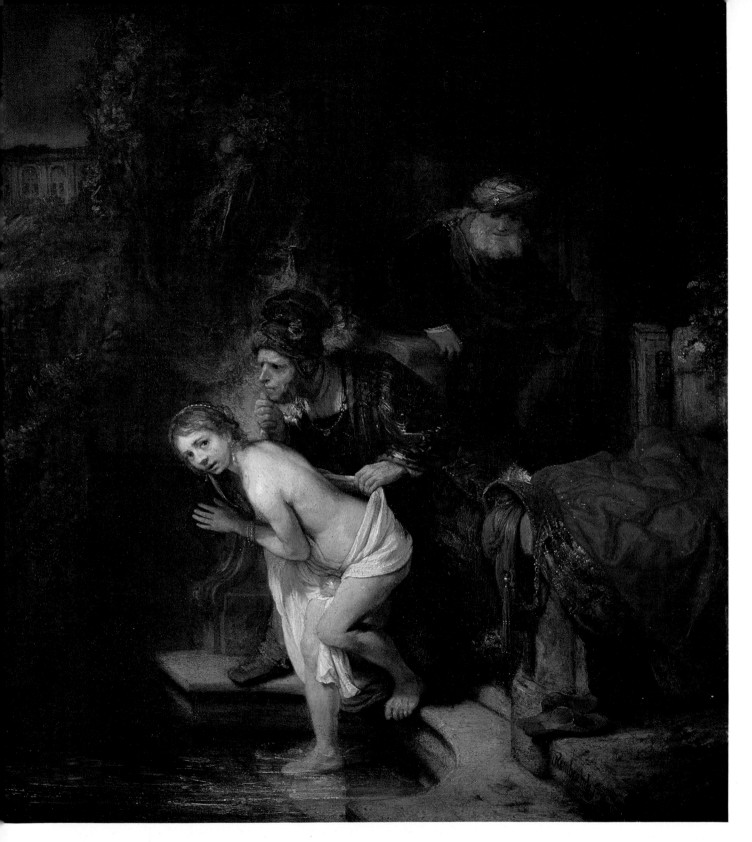

Susanna surprised by the elders
1647
Oil on panel
76 × 91 cm (30 × 35¾ in)
West Berlin: Staatliche Museen
Preussischer Kulturbesitz,
Gemäldegalerie

Although signed and dated 1647 and
painted in the warm, harmonious
style of the 1640s, this picture
relates to earlier studies of the same
subject, in particular the painting in
the Mauritshuis at The Hague (see
page 37). Indeed, X-ray photography
has shown that the present painting
was reworked by Rembrandt and
consists of two layers: the first of
about 1635 and the second of 1647.
It is doubtful if, in reworking it,
Rembrandt improved on the
psychological interpretation of the
incident. Unlike the Susanna in the
painting at The Hague, who is
genuinely startled by the spectator's
presence, this later version has an
almost knowing look, as if she might
be posing for a risqué scene. The red
drapery on the right and the barely
repressed sexuality of the first elder
are, however, beautifully observed.
The landscape and buildings in the
background have affinities with
those in *The reconciliation of David
and Absalom* (page 39) painted about
five years previously.

Aristotle contemplating a bust of Homer
1653
Oil on canvas
143.5 × 136.5 cm (56½ × 53¾ in)
New York: Metropolitan Museum of Art

We know from the inventory of Rembrandt's possessions drawn up in 1656 that he acquired busts of Homer, Socrates, and Aristotle. It is therefore not altogether surprising that when Count Antonio Ruffo, a collector from Messina in Sicily, commissioned a 'philosopher, half length' from Rembrandt that he should think of this subject. Aristotle was not only an interpreter of Homer but the accepted classical philosopher of the Dutch Protestants. The picture was despatched to Sicily in 1654, and we know from documents published by a descendant of Ruffo in 1916 that, although the Count later asked two Italian artists, Guercino and Mattia Preti, to paint companion-pieces, he turned again to Rembrandt for *Alexander* and *Homer*, which Rembrandt sent in 1661 and 1662 to complete the set. The painting is one of Rembrandt's most powerful portraits of a philosopher, illumined with a dramatic historical imagination.

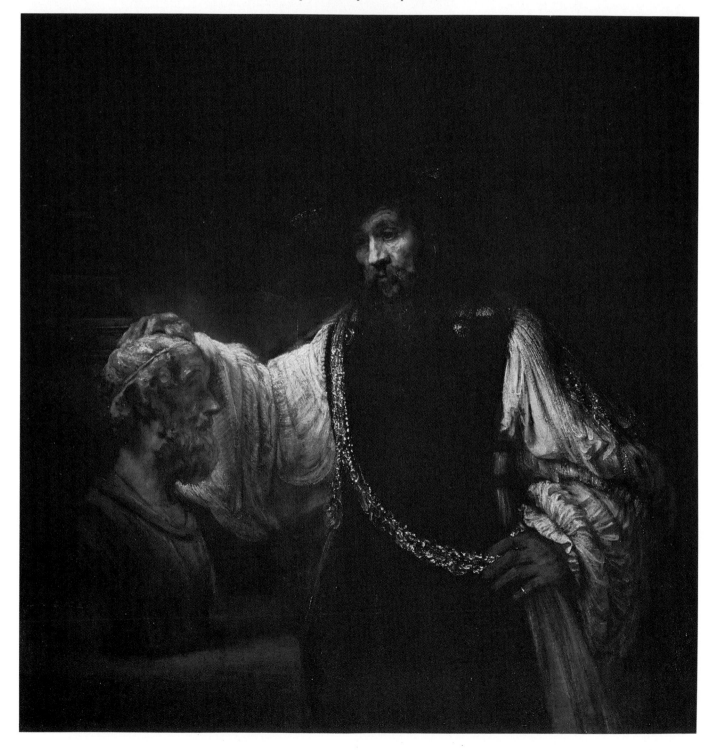

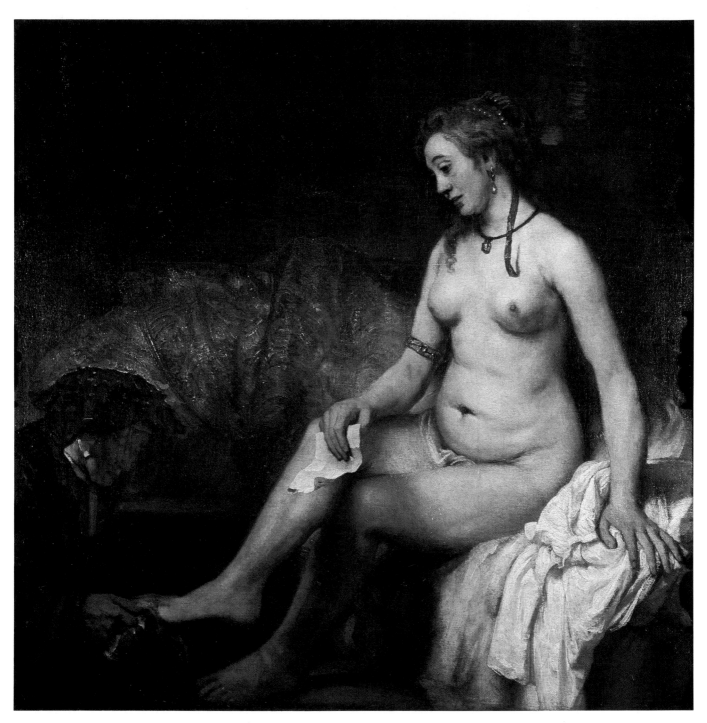

Bathsheba with King David's letter
1654
Oil on canvas
142 × 142 cm (56 × 56 in)
Paris: Louvre

This beautiful painting is not only Rembrandt's most successful nude, but one of the greatest paintings of the nude in Western art. The model is undoubtedly Hendrickje, and although her ample form, short thighs, and large hands have been described as those of a peasant, the painting is so sensitively composed, with such an ineffable look of sadness in the face, that such remarks appear mere carpings when one examines the painting as a whole. Rembrandt's search, in any case, was not for classical beauty but for the most effective means of telling the story in terms of human gesture. In this he succeeds superbly: the figure was no doubt painted from life, but not without trial and error, as X-rays have revealed that Bathsheba was at first painted looking upward. What is remarkable, however, is that the pose is taken from a book of engravings of antique sculptural fragments by François Perrier, published in Paris in 1645. Rembrandt has transformed it out of all but the scholar's recognition.

A woman bathing
1654 or 1655
Oil on panel
61.5 × 47 cm (24½ × 18½ in)
London: National Gallery

This charming painting may have
been done in connection with an
idea for a Susanna and the elders,
but if so the elders were forgotten
and nothing disturbs the smile on
the face of the woman in these
idyllic surroundings. The picture
was at some time overpainted, but
when it was cleaned in 1946 it
revealed the way in which
Rembrandt had painted thinly,
almost 'luminously' in parts,
allowing the ground to shine
through. The treatment of the
model's right hand and wrist, which
before had been 'correctly' finished,
was now revealed in all its summary
sureness and vivacity. The identity
of the bather is uncertain, but
comparison with other paintings of
Hendrickje Stoffels suggests that it
is indeed her, but treated by
Rembrandt as a model rather than
as a sitter for a formal portrait.

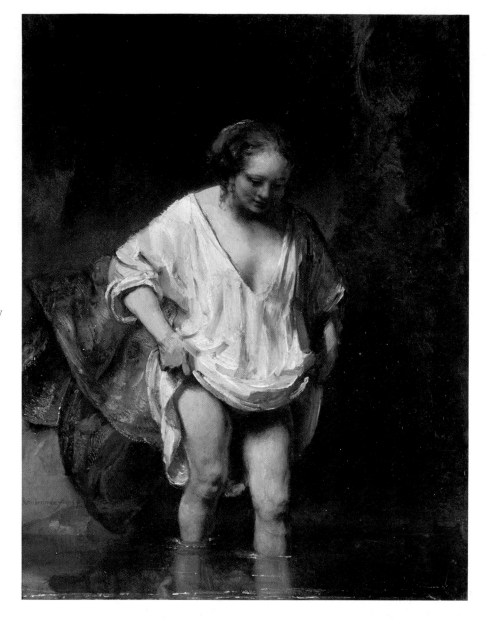

Portrait of Jan Six
1654
Oil on canvas
112 × 102 cm (44 × 40½ in)
Amsterdam: The Six Foundation

The painting is not dated, but its
date was recorded in a form of
anagram Jan Six wrote in Latin in
his album: 'Such a face had I, Jan
Six, who since childhood have
worshipped the Muses' (the capital
letters of the Latin, when added up
as Roman numerals, ingeniously
make 1654). Six was both a
merchant and a man of letters; he
seems to have befriended Rembrandt
in the early 1640s. In 1647

Rembrandt etched his portrait,
showing him reading with his arm
resting on a cushion by a window.
The image is that of a young poet,
not a business man. Two years
before this portrait was painted, Six
gave up his business in order to
concentrate on public affairs (he was
to become burgomaster of
Amsterdam in 1691). The painting of
this portrait, one of Rembrandt's
greatest outside his series of self-
portraits, seems to have been the
last contact between the two men.
It is remarkable for the vigorous
treatment of the cloak and glove,
and the psychological insight in the
rendering of the face.

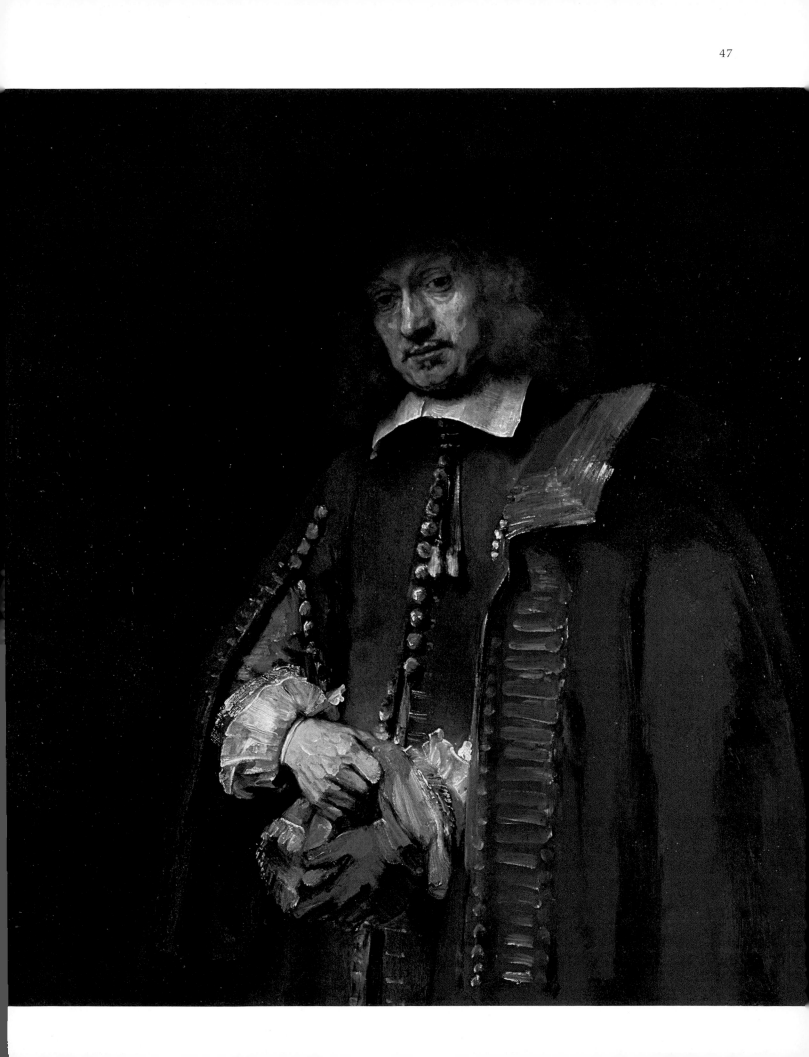

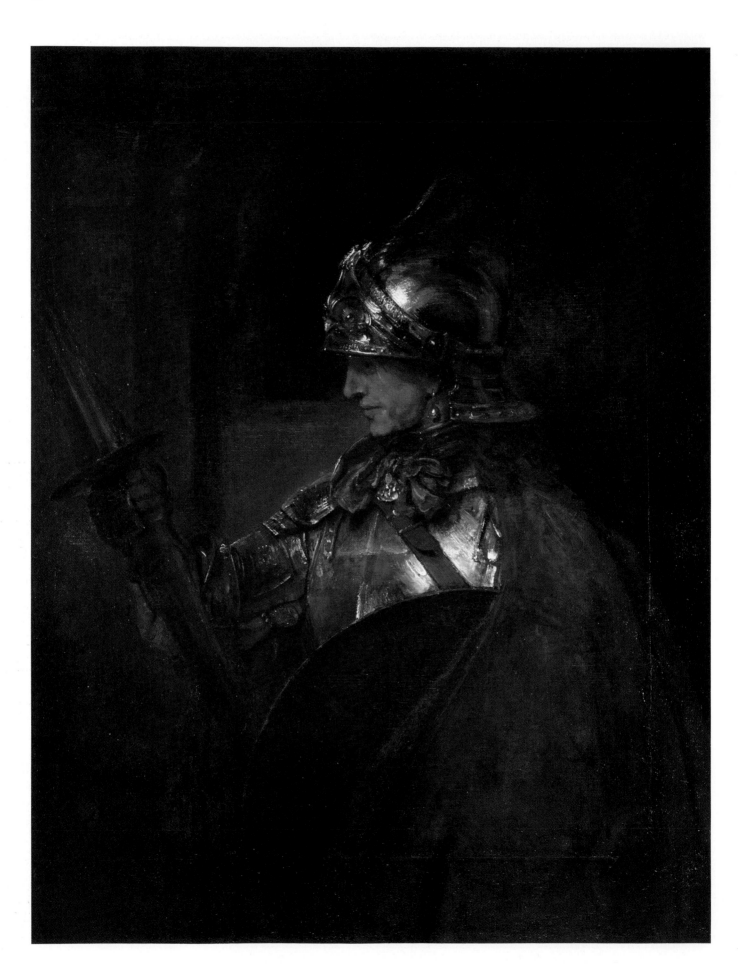

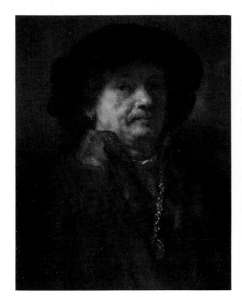

Self-portrait
1655
Oil on panel
66 × 53 cm (26 × 21 in)
Vienna: Kunsthistorisches Museum,
Gemäldegalerie

This self-portrait was painted only
three years after the heroic large
Self-portrait in painting clothes (also
at Vienna: see page 42). But the
look in his eyes is now more wary,
and the flesh of his face has grown
looser. He wears a fur-lined leather
coat with a high, uncomfortable
collar to keep out the cold; but the
gold chain with its pendant and the
ear-ring are still worn with the old
élan. Rembrandt's financial troubles
were gathering, and it is perhaps not
reading too much into this portrait
to see a look of defiant retreat. The
condition of this painting is poor,
but it is hardly the 'beautiful ruin'
described by some scholars.

Alexander the Great
Dated 1655; finished 1661
Oil on canvas
137.5 × 104.5 cm ($54\frac{1}{8}$ × $41\frac{1}{8}$ in)
Glasgow: Art Gallery and Museum

Long thought to be a doubtful
Rembrandt because it contains more
recent additions, this is in fact one
of two Alexanders that Rembrandt
painted for the Sicilian nobleman
Antonio Ruffo. The first of these was
despatched by Ruffo's agent in
Amsterdam in July 1661. Ruffo
later complained it was really only a
head to which Rembrandt had
added strips of canvas to make it up
to the size of the *Homer* already in

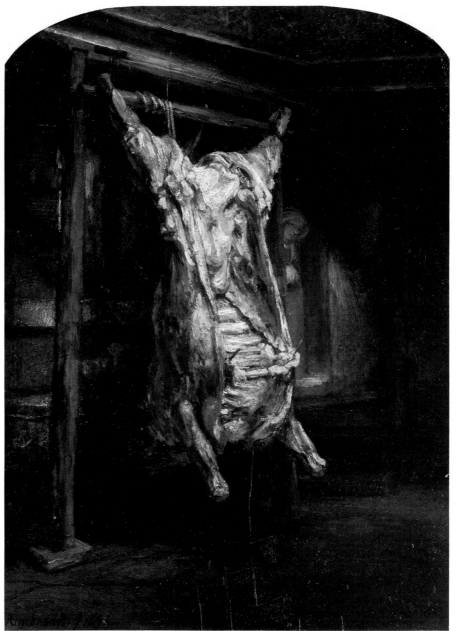

his collection. Rembrandt painted
another Alexander (today in the
Gulbenkian Collection at Lisbon),
and it is now generally accepted that
the Glasgow picture, in spite of the
additions, is Rembrandt's first
version, probably adapted from a
study of his son Titus.

The slaughtered ox
1655
Oil on panel
94 × 67 cm (37 × $26\frac{1}{2}$ in)
Paris: Louvre

Rembrandt painted a similar study
of a slaughtered ox (now at Glasgow
Art Gallery) in the late 1630s. It

shows a bending woman in the
background mopping the floor with
a cloth, and lacks the
uncompromising directness and
freedom of handling of this later
version. The woman is still there,
but she has been relegated to a
subordinate position, peering behind
the far post, and the carcase thrusts
out its dreadful weight into the
picture space unimpeded. The
painting has had a special attraction
for other artists ever since it was
acquired by the Louvre in 1857. It is
a painter's painting: a work as much
about painting itself as about its
repellent subject. Delacroix and
Soutine are two of the many artists
who have made copies of it.

The Last Years

The mid-16th century brought a period of economic depression to the Netherlands, due partly to the upheavals of the Anglo-Dutch War. In 1653 Jan Six lent Rembrandt 1,000 gilders to enable the latter to pay off the outstanding purchase money on his house. Six had got married, and in 1655 he sold Rembrandt's bill of credit to a merchant, who then foreclosed on the guarantor of the loan, Rembrandt's faithful friend Lodewijk van Ludick. This was the start of Rembrandt's renewed financial troubles, which had lain dormant for some years owing to the tolerance of his main creditors over the house. It led to his bankruptcy hearing in 1656, and eventually to the sale of his art collection. But just as his great masterpiece 'The night watch' had been painted in the year of Saskia's death, so the year of his bankruptcy is marked by his second great painting of a Dutch surgeon. This is the *Anatomy lesson of Dr Johan Deyman* (now in Rijksmuseum, Amsterdam), a solemn but realistic group portrait, showing the corpse foreshortened in the manner of Mantegna's *Dead Christ* in the Brera gallery, Milan. (Unfortunately, the painting was burnt in the 18th century and only a fragment survives.)

With the money borrowed from Jan Six and others, Rembrandt had been able to have the deeds of his house made out in his own name. In 1655 he attempted to buy another, cheaper house, in the Hooghstraat with his friend the art dealer Abraham Francken as witness. For some reason this sensible idea never came to anything, and the following year Rembrandt tried to improve an impossible situation – he had borrowed more money to discharge his earlier debts – by transferring the deads of his house to Titus. In July 1656 Rembrandt was forced to apply for the liquidation of his property and to declare his true financial situation. He blamed his poor state on losses 'in trade and at sea', but this was probably a legal fiction. One of the members of the tribunal was Jan Six's brother-in-law, and one can perhaps understand Six's reluctance to get involved in the hearings. The petition was accepted and late in July the Court of Insolvency drew up an inventory of Rembrandt's possessions, no doubt with his necessary help. The list of 363 items is in the state archives at Amsterdam and gives a fascinating room-by-room account of the contents of the painter's house in the Breestraat. It begins with 'One small picture of Adrian Brouwer, representing a pastry cook', and continues through paintings, furniture, sculpture, helmets, engravings, drawings, books, weapons, musical instruments, and animal skins to 'Linen at the Laundry'.

In 1657 the court authorised the bailiff to arrange for the first sale of Rembrandt's possessions at an inn in the Kalverstraat. The following year the house was sold, but court actions delayed the taking of possession, and Rembrandt probably did not move until December 1660. It fetched considerably less than Rembrandt had paid for it – a reflection of the economic climate at the time. A further sale was held of Rembrandt's prints and drawings, but these, too, fetched deflated prices. A legal wrangle ensued over the share due to Titus, and Rembrandt (who was no longer his legal trustee) was at pains to establish that the valuation of the estate drawn up some years after Saskia's death in 1647 was not over-optimistic. It was in this connection that Rembrandt's friends and former patrons, including two of the members of Banning Cocq's militia company, gave evidence of the fees he had received. The valuation was eventually accepted, and Titus's share, on paper, was 20,000 gilders. In the event he received only 6,952 gilders, which came from the sale of the house.

By 1661 Rembrandt was at last free: his debts were settled, or no longer enforceable, or had been taken over by his friends. He had moved the previous year with his family to lodgings on the other side of the city,

Hendrickje Stoffels
c. 1654–6
Oil in canvas
102 × 85.7 cm (40$\frac{1}{8}$ × 33$\frac{3}{4}$ in)
London: National Gallery

There has been much discussion of the date of this painting, arising from the difficulty experienced in the past in reconciling the signature (and the date painted beside it) with the stylistic evidence and the age of the sitter. It was bought in Amsterdam in 1817 by the dealer William Buchanan for a Mr Edward Gray of Hornsey, and it later entered the collection of James Morrison, a business man, of Basildon Park. Some time during the 19th century the picture was 'toned' with water-colour and given a heavy coat of varnish which, as it discoloured, made the portrait (and signature) very difficult to read. It was only in 1976, when the painting was cleaned after being bought by the National Gallery from the Morrison Collection, that the signature was discovered to be false. X-rays also showed that the sitter's hands had originally been folded in her lap. At one time the portrait was thought to be of Rembrandt's daughter Cornelia; in fact, it was almost certainly painted within two years of her birth. It is now known (and will be evident from a glance at pages 46 and 55) that this broadly painted, affectionately posed portrait is of Rembrandt's mistress – and Cornelia's mother – Hendrijcke in about her 30th year.

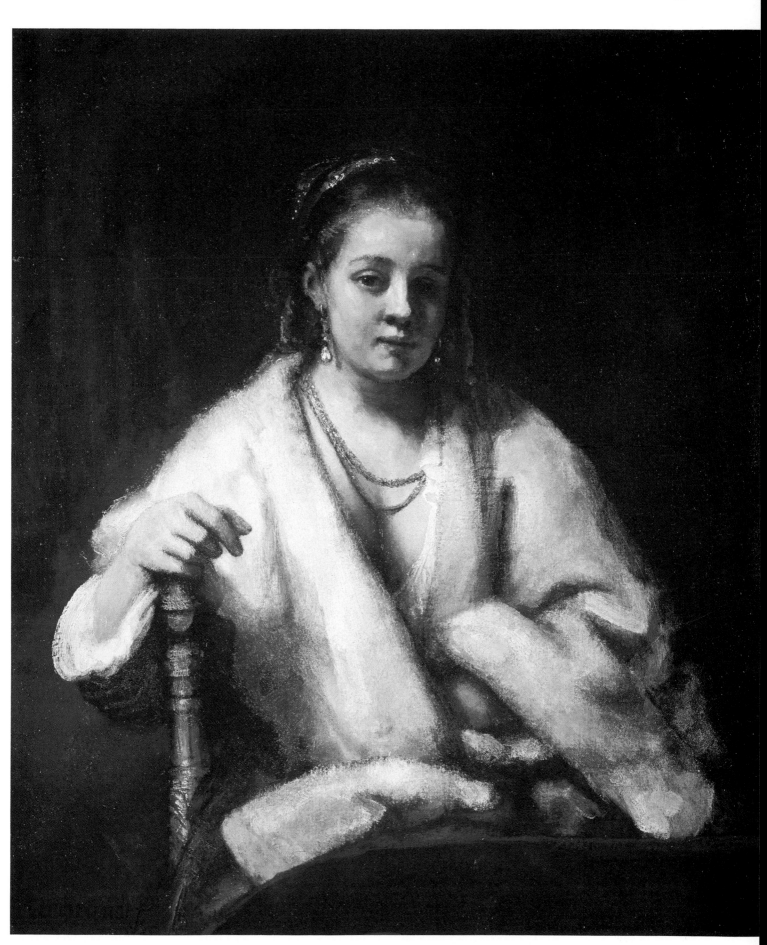

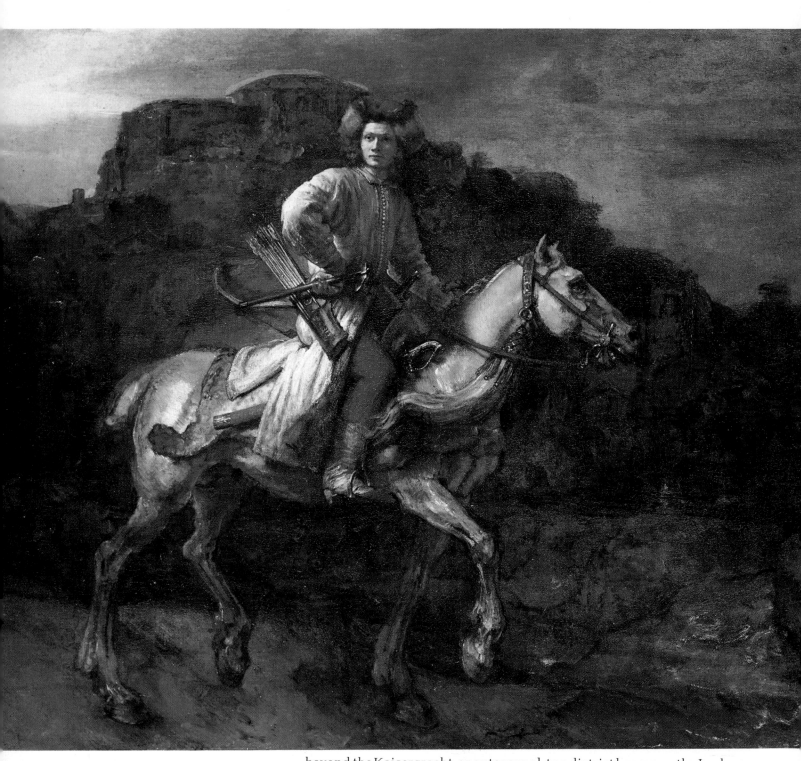

beyond the Kaisergracht, or outer canal, to a district known as the Jordaan. Here he found peace and the strength to absorb himself in the private world of his imagination. He continued to paint, but he was no longer allowed by the artists' Gild of St Luke to trade in his work. The loyal Hendrickje and Titus, however, came to the rescue by forming a company, of which Rembrandt became an employee, handing over his paintings in return for board and lodging. But he was not forgotten: he continued to have pupils, to paint commissions, and even to inspire poems, including one by his former pupil Jeremias de Decker, praising his work.

Two of his noblest paintings stem from these years. The first was *The conspiracy of Julius Civilis: the oath* (also known as *The conspiracy of the Batavians*), painted for the New Town Hall in 1661, but removed two years later; it survives, alas, only as a fragment (see page 59). The second

'The Polish rider'
c. 1655–6
Oil on canvas
116.8 × 134.9 cm (46 × 53⅛ in)
New York: Frick Collection

This image of a 'Polish' horseman has been variously interpreted: as an ideal concept of the 'Christian soldier'; as a portrait of Gysbrecht van Amstel, the supposed founder of the city of Amsterdam; or as a symbol of the struggle for Polish liberty. The picture entered a Polish collection late in the 18th century, and Polish historians have confirmed that the costume, arms, and accoutrements are indeed Polish. Rembrandt based the image of horse and rider on a drawing he had made of a skeleton of a man on the skeleton of a horse which stood in the Anatomy Theatre at Amsterdam. He no doubt saw this when painting *The anatomy lesson of Dr Johan Deyman* in 1656. Rembrandt may well have had some sympathy with the religious sect known in Holland as the 'Polish Brethren' and in their struggle for liberty of conscience. The brethren had found support for their cause among the Dutch Mennonites, and Rembrandt is known to have had contact with them through the Ulenborch family. In any case *'The Polish rider'* remains an ideal symbol of the struggle of the oppressed anywhere.

Titus reading
c. 1656
Oil on canvas
70.5 × 64 cm (27¾ × 25¼ in)
Vienna: Kunsthistorisches Museum, Gemäldegalerie

Titus was Saskia and Rembrandt's only child to survive. He was born in 1641, and so was about 15 when this portrait was painted. He was trained as an artist by his father, and he became a partner with Hendrickje Stoffels in the art-dealing business that was set up to assist Rembrandt and provide a livelihood for the household after the bankruptcy in 1656. This painting of an attractive youth reading (aloud?) is one of the happier portraits of Titus, made all the 'sunnier' by the strong shaft of natural light which falls so naturally over his right shoulder on to his book. Titus was a sickly youth and died in the same year as his marriage in 1668. His posthumous daughter, born the following year, was named Titia after him.

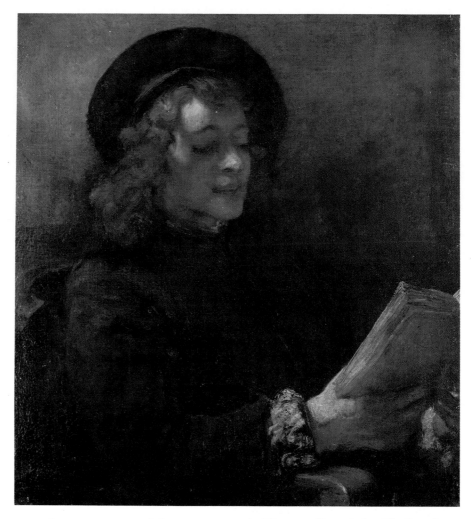

was the more successful group portrait, *The syndics of the Clothmakers Gild* ('*De Staalmeesters*') (see pages 58–9), painted in 1662 to hang in their hall, the Staalhof. This is unquestionably one of Rembrandt's greatest paintings, less dramatic than '*The Night Watch*', but full of a mature psychological observation that gives it a feeling of intense naturalism. Some of his most heroic portraits were to be painted in this last decade.

Money, however, was still a problem; on one occasion he was even forced to sell Saskia's grave in the Oude Kerk. Hendrickje was ill, and when she made her will in August 1661 she was described as 'sick in appearance, though still on her feet and active'. She died on 24 July 1663 and was buried in the Westerkerk, a short walk from the house in which they had lived. Titus continued the art dealing business, having been declared 'of age'; but he, too, was sickly. In February 1668 he married the daughter of Rembrandt's old friend, the silversmith Jan van Loo, but seven months later was dead. He also was buried in the Westerkerk. Rembrandt was left, old before his time, with his teenage daughter, Cornelia. The last self-portraits show the soft face of an old man, resigned, no longer resolute. He died on 4 October 1669, almost unnoticed, and was buried beside Hendrickje and Titus in the Wester-kerk. Two years before, in 1667, he had been visited by Cosimo de Medici, later to become Grand Duke of Tuscany. One would give much to know what took place at that interview between the scion of the greatest house of Florence and the elderly Dutch painter, no less proud for all his poverty and paint-stained clothes. Cosimo apparently found nothing to his liking in the studio that day, but when he returned to Florence he probably took with him one of the self-portraits which were to form part of the great Medici collection at the Uffizi gallery. The old man was a painter whose pictures even princes could not afford to ignore.

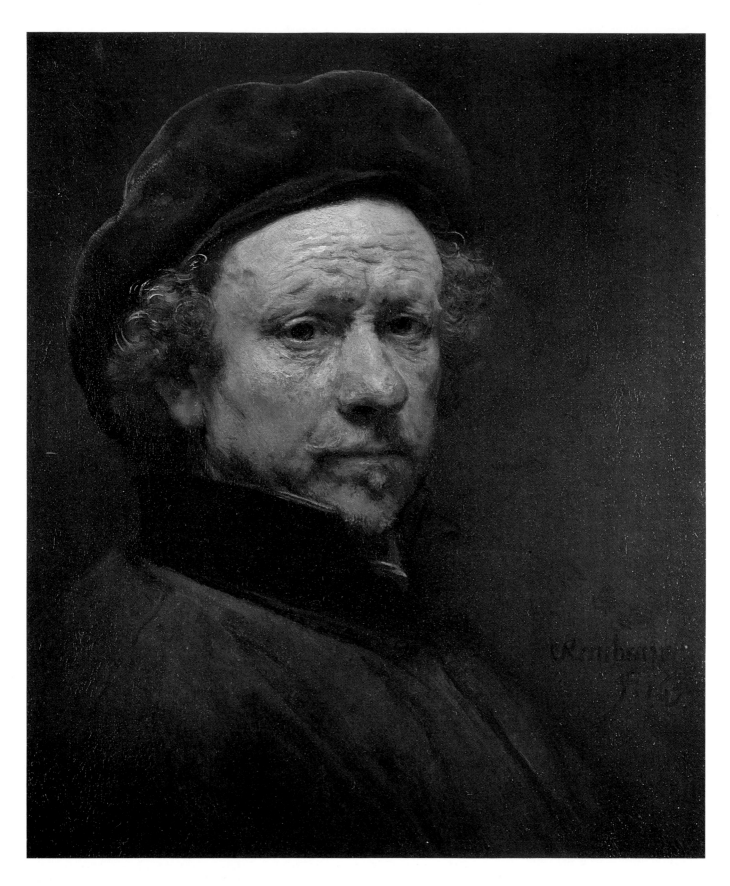

Self-portrait
1657
Oil on canvas
50 × 42.5 cm (19¾ × 16¾ in)
Edinburgh: National Gallery of
Scotland (on loan from the Duke of
Sutherland)

Of all Rembrandt's self-portraits –
and he painted more than 60 – this is
the most carefully wrought, the most
realistic. As one comes upon it in
the National Gallery in Edinburgh
the sense of life-likeness is uncanny:
in artificial light, especially, it can
look like an enlarged colour
photograph; yet close scrutiny
shows that the paint has been laid
on *as paint* and not in imitation of
flesh. Rembrandt has built up the
wrinkled brow, the puckers of skin,
in very satisfying passages of reds
and ochres that can be appreciated
as paint in their own right. It is only
when one stands back that the
whole resolves into what is the most
detailed statement of an artist's face
ever attempted. It was painted when
Rembrandt was 50, in the year in
which the first sale of his
possessions took place as part of the
liquidation of his property. Perhaps
this accounts for its searching
examination of character; and yet the
total effect is one of indomitable spirit
and strength.

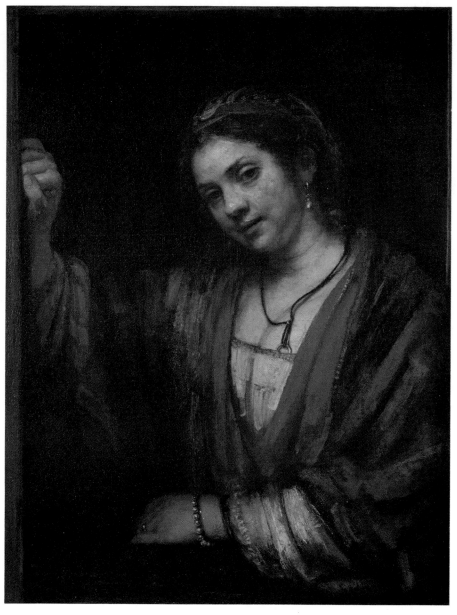

**Hendrickje Stoffels leaning against a
door**
c. 1656 or 1657
Oil on canvas
86 × 65 cm (34 × 25½ in)
West Berlin: Staatliche Museen
Preussischer Kulturbesitz,
Gemäldegalerie

This moving, simple portrait of a
woman standing as if at a half door,
with her hand resting on the
opened, upper half, strikes one as
typically Dutch: it is the sort of
composition that Nicolaes Maes, a
pupil of Rembrandt, often painted.
But its source, as so often with
Rembrandt, lies in Venetian art.
Titian's *Flora* was in the collection
of Alfonzo Lopez in Amsterdam, and

Rembrandt also seems to have been
aware of the type of opulent female
portrait by Palma Vecchio
(1480–1528), one of which was sold
from the Andrea Vendramin
collection in Amsterdam in the
1640s. That does not, of course,
make this portrait of Hendrickje an
imitation: we know from X-rays, in
fact, that Rembrandt reworked this
picture quite extensively. Hendrickje
was originally seen full face, and the
lovely gesture of the hand held
against the woodwork at eye level
was a later development. What
might be considered as a 'come-
hither' pose in a lesser artist's work
is transformed by Rembrandt into a
powerful and sympathetic image of
female sexuality.

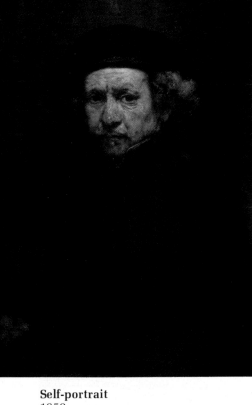

Self-portrait
1659
Oil on canvas
84.5 × 66 cm (33¼ × 26 in)
Washington: National Gallery of Art
(Mellon Collection)

This portrait was painted two years
after the searching, almost
photographic image of the portrait
on loan to the National Gallery of
Scotland (page 54), which in many
ways it resembles. Rembrandt wears
the same cap, but at a less jaunty
angle; the coat appears to be the
same, with its turned-up collar and
heavy seam along the shoulder. But
the face is more pinched, the eyes
are larger, almost fearful. The year is
1659, and the bankrupt Rembrandt's
possessions have been sold; he lives
on in the house in the Breestraat,
but only on sufferance because the
new owner cannot yet move in. His
portraits at this period alternate
understandably between defiance
and despair. Gone is the
'philosopher-king' of the noble self-
portrait now in the Frick Collection
(New York), painted the year before;
the troubled brow and eyes of the
smaller self-portrait in Vienna (page
49) have returned, and with them
the rounded shoulders of the *Self-
portrait as the Apostle Paul* (see
facing page). Rembrandt never
descends to self-pity, but this self-
portrait at Washington is the most
melancholic of them all.

Moses with the Tables of the Law
1659
Oil on canvas
167 × 132 cm (65¾ × 53 in)
West Berlin: Staatliche Museen
Preussischer Kulturbesitz,
Gemäldegalerie

This powerful Old Testament
painting is a fragment of a once
much larger canvas, probably
intended as part of a decorative
scheme for the new Town Hall (now
the Royal Palace) in Amsterdam. The
figure of Moses, on the other hand,
is a wonderful example of
Rembrandt's ability to create a
compelling, definitive image of a
biblical figure. As art, it rivals the
Moses that Michelangelo carved for
the tomb of Pope Julius II; but
whereas Michelangelo made a
godlike superman, Rembrandt
painted a strong but human leader,
full of concern for his people as he
holds aloft the Tables of the

Covenant. Although damaged,
Rembrandt's *Moses* remains one of
the greatest religious paintings by
the supreme illustrator of the Bible.

Self-portrait as the Apostle Paul
1661
Oil on canvas
91 × 77 (35⅞ × 30⅜ in)
Amsterdam: Rijksmuseum

Throughout his career Rembrandt
painted single figures of the apostles
and Old Testament prophets. As a
series they are akin to his self-
portraits, being like them a vehicle
for the expression of mood, of states
of mind, or of attitudes to life, as
much as representations of their
ostensible subjects. In 1657
Rembrandt painted two large
apostles, *St Paul at his desk* and *St
Bartholomew*. These may have given
him the idea, or possibly have
attracted a commission, for a 'set' of

apostles, including Christ and the four evangelists, all of which were painted in 1661. The finest of the 'set' are undoubtedly this one and *The Evangelist Matthew inspired by the Angel* (Paris: Louvre). All the paintings in the set are roughly the size of this one. Rembrandt wears the flat, white turban which was to characterise the self-portraits of the 1660s, but his face bears an expression of baffling complexity – part character acting, part self-mocking resignation.

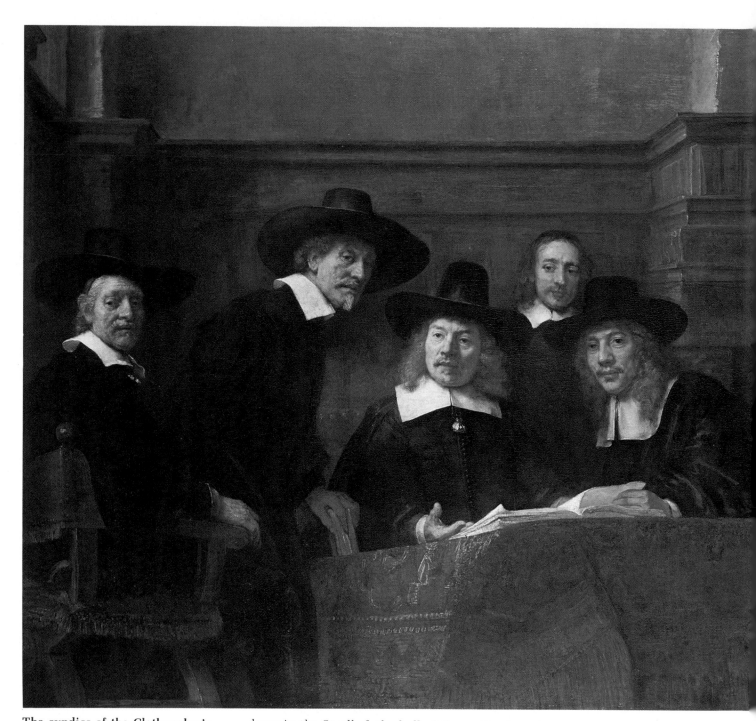

The syndics of the Cloth-maker's Gild ('De Staalmeesters')
1662
Oil on canvas
191 × 279 cm (75¼ × 110 in)
Amsterdam: Rijksmuseum

The syndics was finished in the same year as *The conspiracy of Julius Civilis* (right). Both paintings show a group of intent, earnest men seated at a long table; but while *The conspiracy* is painted with the inspired brush of a visionary, *The syndics* represents the tranquil distillation of a lifetime's observation of human nature. It was painted to

hang in the Staalhof, the hall of the gild, and five of the men (the sixth is a servant) are probably wardens who were appointed annually to control the quality of cloth. The meeting is obviously a public one, for all eyes seem to be directed at a questioner from the floor of the hall. Only three of the wardens have moved: two to refer to the book of samples, or regulations, in front of them, while the third is in the act of half rising from his chair to reply. They are a harmonious group, representative of good government, and yet each is individually differentiated within the whole.

Rembrandt executed several drawings for the figures, but he also made alterations as he went along – the position of the servant was changed until he found his place in the centre of the composition, in a subordinate yet interested role.

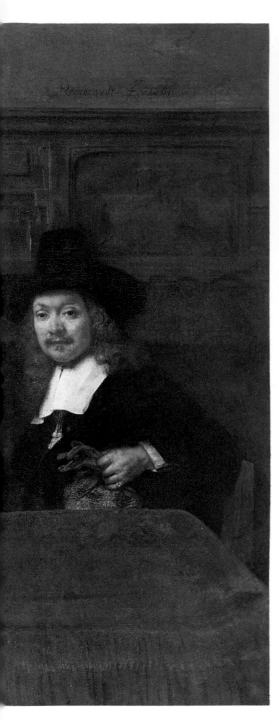

The conspiracy of Julius Civilis: the oath
1661
Oil on canvas
196 × 309 cm (77¼ × 121¾ in)
Stockholm: Nationalmuseum

The new Town Hall of Amsterdam, which replaced the picturesque medieval building (seen in the painting by Pieter Saenredam in the Rijksmuseum), was begun in 1648. In 1655 construction was sufficiently advanced for Govaert Flinck, one of Rembrandt's former pupils, to be commissioned to design a decorative scheme for the Great Gallery. Unfortunately Flinck died in 1660, and the completion of the project seems to have been entrusted to three artists: Jan Lievens, Jacob Jordaens, and a mediocre painter named Jurriaen Ovens. Rembrandt was brought in to decorate a high, arched space with a scene from the story of the 1st century revolt of the Batavians against Rome (which the Dutch saw as a forerunner of their recent struggle with Spain). Rembrandt chose the moment, described by Tacitus, when the one-eyed Julius Civilis, the leader of the Batavians, appealed to his followers at a dinner to swear an oath of allegiance on his sword. Rembrandt's painting was installed by 1662, but was taken down and returned to the artist, probably for some alterations, shortly afterwards. For some reason, perhaps to do with Rembrandt's fee for the overpainting or his intransigence over the changes

required, the painting was never re-hung, but was replaced by a poor copy after Flinck by Ovens. Rembrandt probably cut the painting down to a rectangle to make it more saleable, and we can only imagine its full splendour – like a feast by Veronese under a ruined Roman vault – from a small preparatory sketch now in the Print Room at Munich. The fragment today has grotesque (almost absurd) elements, which once befitted a huge semi-mythological canvas. It is possible to understand the city fathers' unease with the work, but not to condone the enforced destruction of this sublime creation.

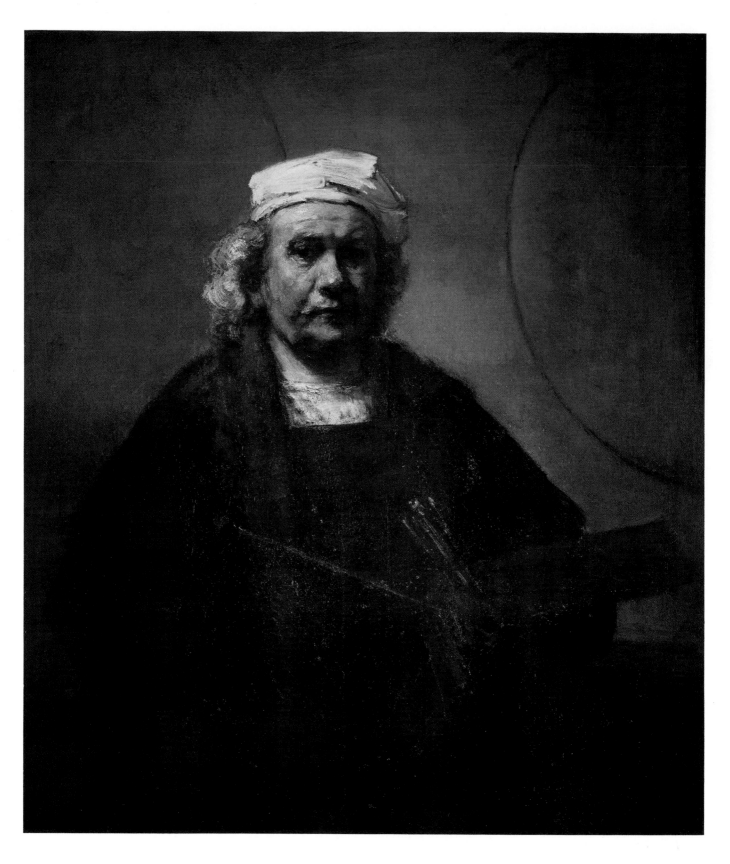

Self-portrait
c. 1655
Oil on canvas
114.3 × 94 cm (45 × 37 in)
London: The Iveagh Bequest,
Kenwood

This portrait was seen in Brussels by the English painter Sir Joshua Reynolds during his tour of the Low Countries in 1781. He described it as being 'in a very unfinished manner, but admirable for its colour and effect'. The full stature of the portrait was seen only after the painting was cleaned for the re-opening of Kenwood House (London) in 1950, when the wedge-shaped edge of the tilted canvas was revealed on the right. Rembrandt has shown himself in the act of painting, and X-rays have confirmed what was already discernible to the naked eye: the selection of brushes and the maulstick were originally held, as in a mirror image, in the painter's right hand, and his left arm once reached across to hold a brush to the canvas. Rembrandt, dissatisfied no doubt with this reversed image, dropped the left arm to support the palette, and at the same time blocked out the right hand, and sharpened the angle of the sleeve. In doing so he transformed the image of a painter into that of the artist as hero, and created the most impressive of his late self-portraits. The 'circles' behind him have been variously interpreted, but they are probably the beginnings of a double-hemisphere wall map of the kind popular as a decoration in 17th-century Holland. Whatever his original intention, Rembrandt left unfinished what already sufficed to stabilise his design.

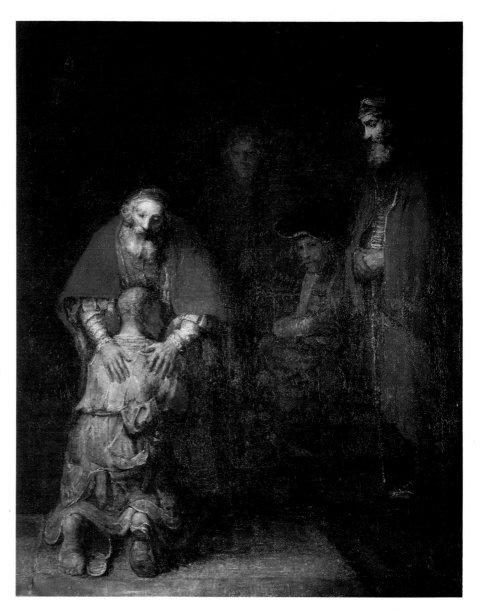

The return of the Prodigal Son
c. 1668
Oil on canvas
262 × 206 cm (103¼ × 81⅛ in)
Leningrad: Hermitage Museum

This late painting has been described as 'one of the great miracles of Rembrandt's art'. It is also one of the most compelling images of human compassion in the history of painting. Father and son are seen fused together in a single vertical form, the prodigal's face hidden in his father's bosom. They have a monumentality akin to the 'sculptural' figures of Masaccio, or to the block of marble out of which a Michelangelo *Pietà* dimly appears. The effect is one of great stillness. Rembrandt can have seen neither of these Renaissance prototypes, and we are forced to the conclusion that he, like other great artists in their maturity, came to a simple, instinctive realisation of the essential language of art, which strips away the superfluous and reveals a common perception of eternal truths. Rembrandt's borrowings, his awareness of the art of the past, here find a triumphant fulfilment which is far beyond the trivial concerns of imitation.

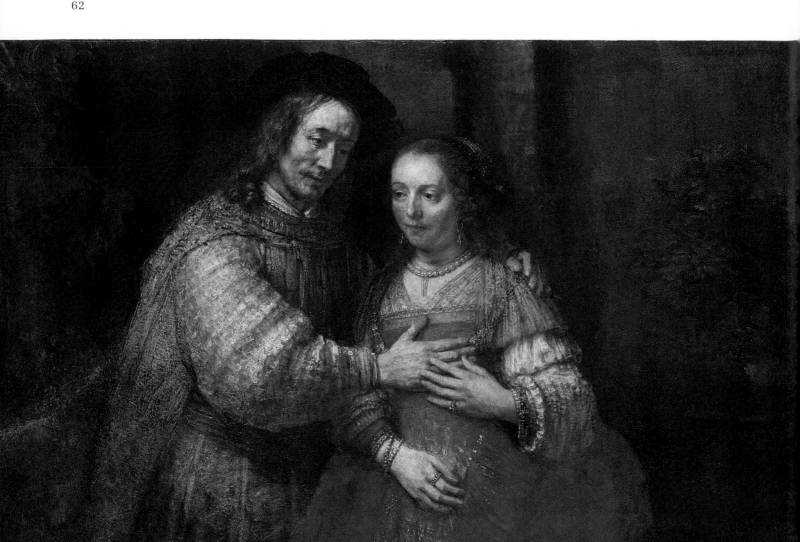

The Jewish bride ('Isaac and Rebecca')
c. 1666
Oil on canvas
121.5 × 166.5 cm (47$\frac{7}{8}$ × 65$\frac{5}{8}$ in)
Amsterdam: Rijksmuseum

This picture is at once the most mysterious and the most poetic of all Rembrandt's portraits. Opinions have differed over whether it represents a biblical story or a real couple, but the distinction is now largely irrelevant. There is a drawing by Rembrandt of Isaac and Rebecca seated in a similar pose, but it dates from the 1630s, while this work was probably painted in 1666, at a time when Rembrandt was in any case inclined to see himself and others in biblical terms. Like the self-portraits, it is above all a painting of mood, of an emotional state – in this case an

expression of both physical *and* spiritual love. *The Jewish bride* is a continuation of Rembrandt's Venetian vein – the picture in which he comes closest in mystery and spirituality to Giorgione (*c.* 1477– 1510). Attempts have been made to identify the couple as Titus and his young bride, but the painting is more likely to be a poetic invention with biblical allusions.

Self-portrait
1669
Oil on canvas
86 × 70.5 cm (33$\frac{7}{8}$ × 27$\frac{3}{4}$ in)
London: National Gallery

This portrait was thought to date from the mid-1660s, or even as early as 1659, before it was cleaned in 1966 and the remains of the

signature and date appeared. It is notoriously difficult to date Rembrandt's self-portraits by his apparent age: this is one of two painted in the last year of his life (the other is in the Mauritshuis at The Hague). X-ray photographs taken during the cleaning revealed that the turban was once white, and also higher and fuller, as in the Kenwood self-portrait (page 60), and that Rembrandt had originally placed the hands farther away from the body, holding a brush and maulstick. It was this discovery that led to a re-dating of the unsigned Kenwood portrait to the mid-1660s. Both portraits originally presented the artist in the act of painting, but later relaxed the pose. The National Gallery portrait shows Rembrandt at the age of 63, flabby cheeked, but still looking quizzically at the world.

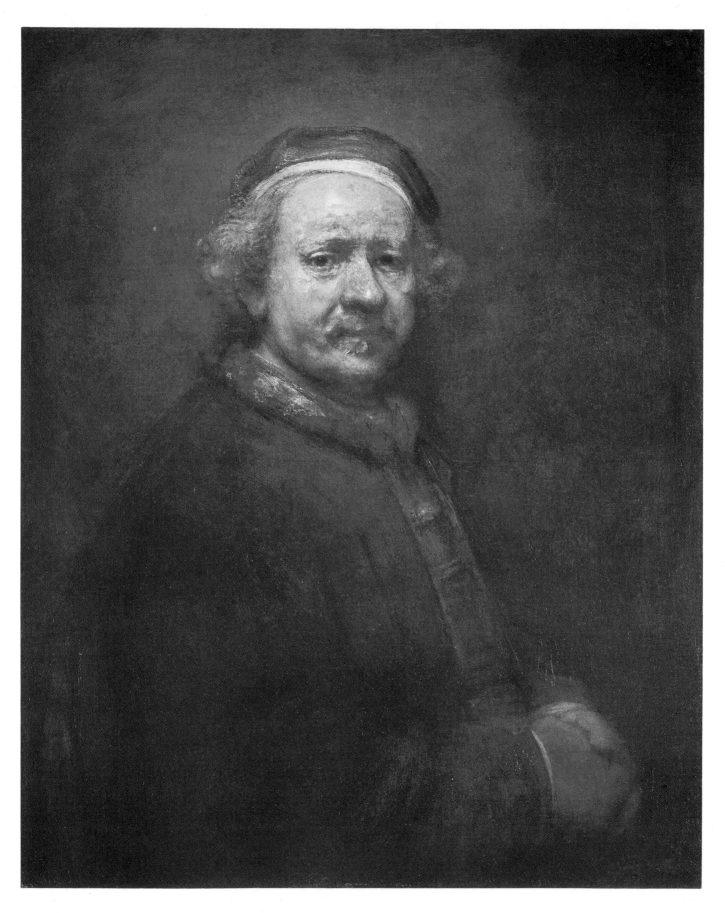

Index

Numbers in *italics* refer to captions

Alba, Duke of 6
Alexander the Great 48, 49
*Anatomy lesson of Dr Johan Deyman,
 The 50, 53*
*Anna accused by Tobit of stealing the
 kid 14*
*Aristotle contemplating a bust of
 Homer 44*
Ascension of Christ, The 32

Backer, Jacob 22
Baldinucci, Filippo *6*
Bassano, Jacopo *27*
Bathsheba with King David's letter 45
Blinding of Samson, The 36
Bol, Ferdinand 22, 27
Buchanan, William *50*
Buytewech, Willem *16*

Caravaggio, Michelangelo Merisi da 14, 35
Castiglione (Raphael) 11, *13*
Charles I of England 19, *21*
*Christ and the woman taken in
 adultery 40*
Circumcision of Christ, The 27
Clark, Sir Kenneth 14, *31*
Cocq, Captain Frans Banning 24
*Conspiracy of Julius Civilis: the oath
 52, 59*

Danaë 35
Decker, Jeremias de 52
Descent from the Cross, The 22, 27
Dircx, Geertge 26, *40*
*Dr Nicholas Tulp demonstrating the
 anatomy of the arm 12–13, 22*
Donne, John 19
Dou, Gerrit 14

Elsheimer, Adam 14, *16*

Feast of Belshazzar, The 31
Flinck, Govaert 22, 27, 59
Francken, Abraham 50
Frederick Henry, Prince of Orange 16,
 17, 19, 22, 24, *26,* 27, 32

Giorgione (Giorgio Barbarelli) *62*

Hals, Frans 24
Heemskerck, Maerten van *14*
Hendrickje Stoffels 50
Hendrickje Stoffels in bed 40
*Hendrickje Stoffels leaning against a
 door 55*
Hobbema, Meindert 8
Huygens, Constantyn 14, 16, 17, 19, 22,
 24, *26,* 32, 36

Jewish Bride, The ('Isaac and Rebecca') 62
Jordaens, Jacob 59
*Judas returning the thirty pieces of
 silver 16, 17*

Kerr, Sir Robert (Earl of Ancrum) 19, *21*
Keyser, Hendrick de 8
Koninck, Philips de 8
Koninck, Salomon de *23*

Landscape with a stone bridge 8
Lastman, Pieter 14, 16
Lievens, Jan 14, 16, 19, *59*

Limborch, Hendrick van *29*
Loo, Jan van 53
Lopez, Alfonzo 9, 11, *13,* 55

Ludick, Lodewijk van 50

Maes, Nicolaes *55*
Man in oriental costume, A 9
Man with the golden helmet, The 11
Mantegna, Andrea, 11
*Maria Trip, daughter of Alotta
 Adriaensdr 11*
Martyrdom of St Stephen, The 14, 16
Medici, Cosimo de' 53
Menasseh ben Israel, Rabbi, 9
*Militia company of Captain Frans
 Banning Cocq ('The Night Watch') 4,
 24, 38*
Morrison, James 50
Moses with the Tables of the Law 56

Nativity 27
'Night Watch, The': see *Militia
 company of Captain Frans Banning
 Cocq, The*

Old man in rich costume, An 40
Ovens, Jurriaen 59

Palma Vecchio 55
Perrier, François *45*
'Polish rider, The' 53
Portrait of Ariosto (Titian) 9, 11, 13
*Portrait of the artist as a young man
 19, 21*
*Portrait of an eighty-three-year-old
 woman 29*
Portrait of Saskia 24
Portrait of Jan Six 29, 46
*Presentation of Jesus in the Temple,
 The 19, 40*
*Prophet Jeremiah mourning over the
 destruction of Jerusalem, The 6*

Raising of the Cross, The 26
Raphael (Raffaelo Santi) 9, 11, *13*
*Reconciliation of David and Absalom
 The 38, 43*
Rembrandt's family: Adriaen (brother)
 11; Cornelia (daughter) 26, *50, 53;*
 Harmen (father) *6;* Neeltge van
 Suydtbroek (mother) *6, 21,* 22, 24;
 Titus (son) 22, 24, 26, *49;* 50, 52, 53
*Rembrandt and Saskia ('The Prodigal
 Son in the Tavern'?) 35*
'Rembrandt's mother' 19, *21*
Resurrection, The 22
Return of the Prodigal Son, The 61
Reynolds, Sir Joshua 61
Rubens, Peter Paul 16, 26, 27, 36
Ruffo, Count Antonio 44, 49

Saenredam, Pieter 59
St John the Baptist preaching 32
*Samson posing the riddle to the
 wedding guests 38*
Saskia as Flora 22, 29
Saskia in a red hat, 27
*Scholar in a room with a winding stair
 22–3*
Self-portrait (1630) 19
Self-portrait (1652) 42, 49
Self-portrait (1655) 49
Self-portrait (c.1655) 61
Self-portrait (1657) 55
Self-portrait (c.1657) 4
Self-portrait (1659) 56
Self-portrait (1669) 62
Self-portrait as the Apostle Paul (1661) 56–7

*Self-portrait at the age of thirty-four
 13, 24*
Six, Jan 24, 27, 29, 32, 46, 50; *Medea 27*
Slaughtered ox, The 49
Stoffels, Hendrickje 26, 40, 45, 46, 50,
 52, *53,* 55
Susanna surprised by the elders (1637) 36
Susanna surprised by the elders (1647) 43
Swanenburgh, Jacob van 14
*Syndics of the Clothmakers' Gild, The
 ('De Staalmeesters') 53, 58*

Titian (Tiziano Vecellio) 9, 13, 32, 35, 55
Titus reading 53
Tribute money, The 17
Tulp, Dr Nicolaes 12, 29

Uffelen, Lucas van 9
Ulenborch, Saskia van (Rembrandt's
 wife) 22, 24, 26, 29, 35, 50
Ulenborch, Hendrick van 22, 24

Veronese (Paolo Cagliari) *31*

Wassenhove, Françoise 29
William, Prince of Orange 6
Winter landscape 4
Woman bathing, A 46

Acknowledgements

The publishers thank the following
organizations and individuals for their
kind permission to reproduce the
photographs in this book:
Reproduced by Gracious Permission of
Her Majesty the Queen 20; Alte
Pinakothek, Munich (Robert Harding)
26, (Scala) 27, (Scala) 33; Bildarchiv
Preussischer Kulturbesitz, West Berlin
back jacket and 10, 32, 42–3, 55, 56
right; Dresden Art Gallery (Cooper-
Bridgeman Library) 35; Frick
Collection, New York 52; Glasgow Art
Gallery 48; Mr L. B. Bogdanov/The
Hermitage Museum, Leningrad 34, 39,
61; G.L.C., Iveagh Bequest, Kenwood,
London (Cooper-Bridgeman Library) 60;
Kunsthistorisches Museum, Vienna 1,
42 left, 49 left, 53; Foundation Johan
Maurits van Nassau: Mauritshuis, The
Hague (Scala) front jacket, 12–13; 19,
37; Musée du Louvre, Paris (Michael
Holford) 22–3; 45, 49 right;
Metropolitan Museum of Art, New
York 44; Musée des Beaux-Arts de
Lyon 16; National Gallery of Canada,
Ottawa 17 above; Reproduced by
Courtesy of the Trustees, The National
Gallery, London 13 left, 28, 29, 30–1, 40
right, 46, 51, 63; National Gallery of
Scotland, Edinburgh (Cooper-
Bridgeman Library) 41, 54; National
Gallery of Art, Washington, D.C.:
Andrew W. Mellon Collection 56 left;
Nationalmuseum, Stockholm 56 right;
private collection (UK) 17 below;
private collection (Netherlands) 18;
Rijksmuseum, Amsterdam 2–3, 7, 8–9, 9
left, 11, 15, 24, 57, 58–9, 62; Six
Foundation, Amsterdam (Cooper-
Bridgeman Library) 47; Staatliche
Kunstsammlungen, Gemäldegalerie,
Dresden 38; Staatliche
Kunstsammlungen, Kassel 4–5, 25;
Städelsches Kunstinstitut, Frankfurt
36; The Marquess of Tavistock,
Woburn Abbey, Bedfordshire 40 left;
Walker Art Gallery, Liverpool 21

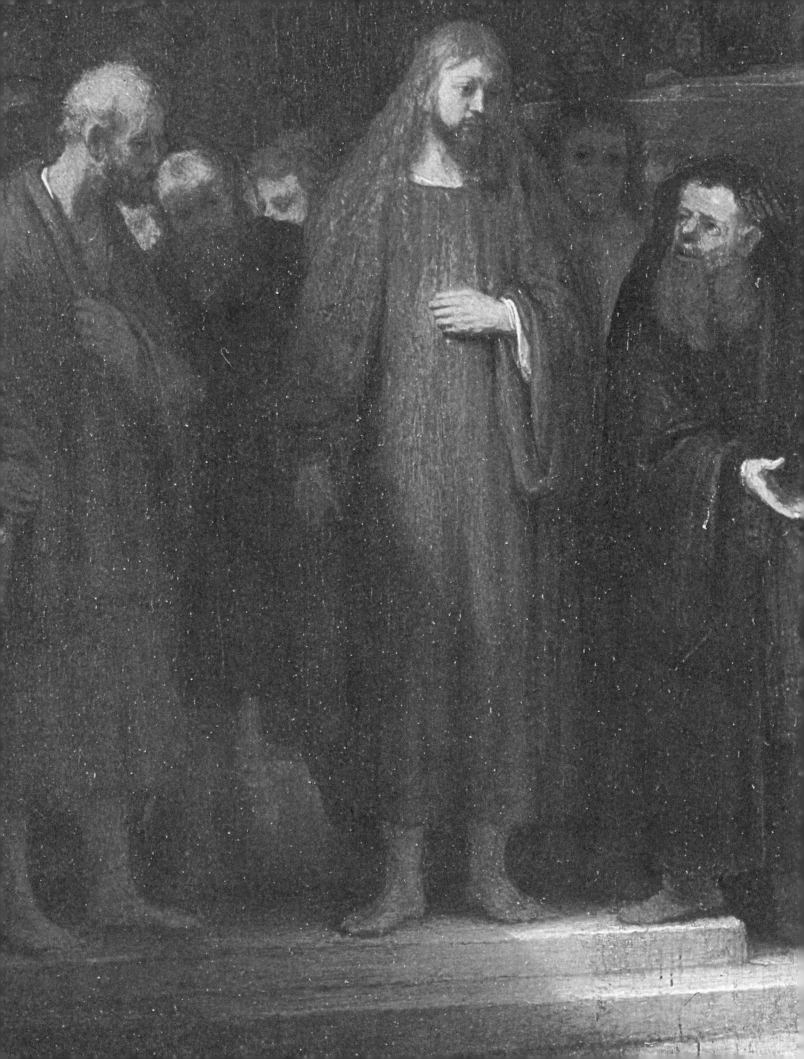